Harry Potter

™

FILM VAULT

VOLUME 6

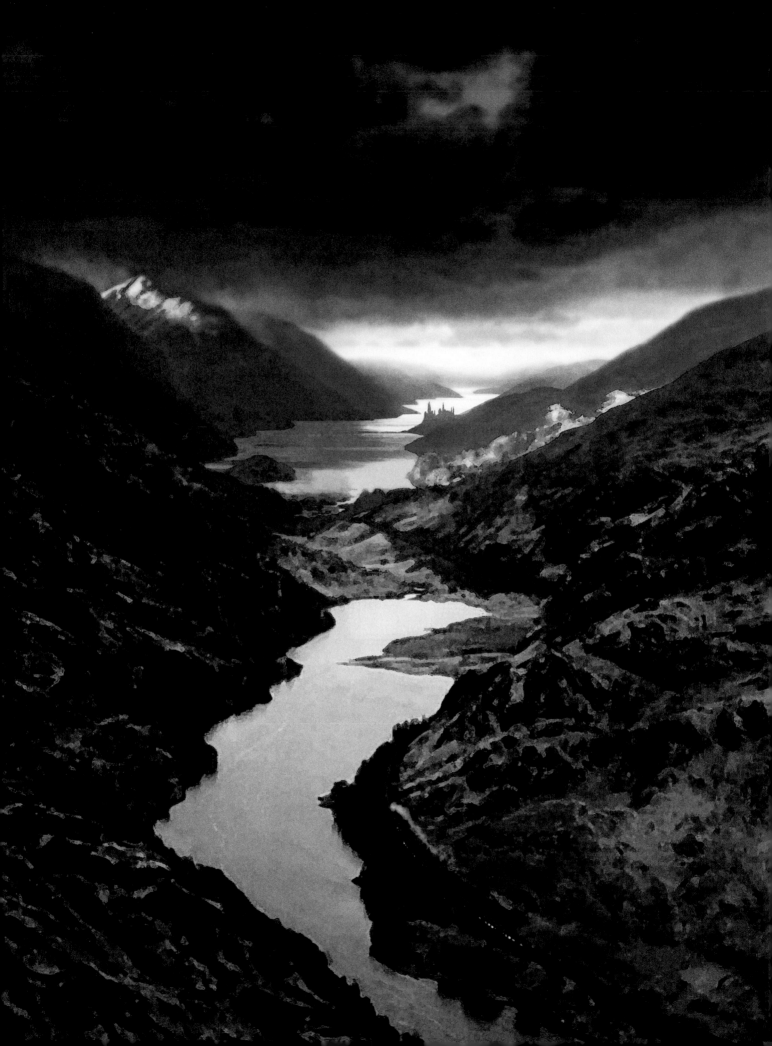

FILM VAULT

VOLUME 6

Hogwarts Castle

By Jody Revenson

WIZARDING WORLD

INSIGHT EDITIONS

San Rafael · Los Angeles · London

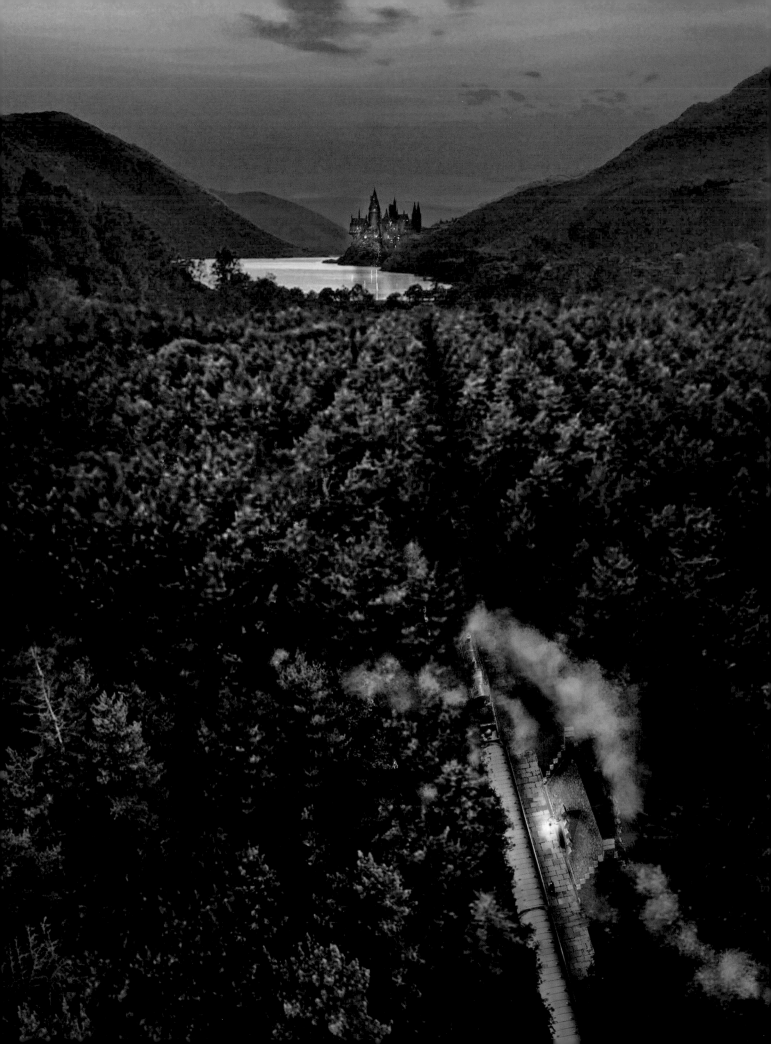

Nestled among the forest-covered hills and mountains of the Scottish Highlands is a castle dating back a millennium that becomes a home for the students and professors of Hogwarts School of Witchcraft and Wizardry. Beside the castle, a large, black lake and a Forbidden Forest host magical creatures. Inside, its Great Hall hosts feasts under a canopy of floating candles. Library books shelve themselves, paintings talk, and the staircases move.

Production designer Stuart Craig was chosen to bring the Wizarding World of J. K. Rowling's novels to the movie screen, and he welcomed any opportunity to talk with the author about the castle and its surroundings. At their first conversation, Rowling drew him a map of Hogwarts and its grounds—a map that Craig referred to throughout ten years of filming Harry Potter's story. "It was," he concedes, "the ultimate authority."

An early decision was not to make Hogwarts castle whimsical, not to make it a fairytale fortress, but to make it heavy, enduring, and real. "I think lots of English public schools are like that," says Craig. "And this is a story about an English public school, really. So, we made it as much like one as we possibly could."

Craig believes that in designing a movie's set or location, the aim is to find a way of exaggerating things theatrically, "but in a good sense," he explains. He does this by deciding on one strong and simple idea and not diluting it with subsidiary ideas. One challenge was that as Harry Potter's story grew, so did the castle—in order to accommodate new classes, characters, and plot points. In *Harry Potter and the Prisoner of Azkaban*, director Alphonso Cuarón worked with Craig to create a connected geography for the school. Adding a long wooden bridge that ends at a group of standing stones on a hill and then leads down to the gamekeeper Rubeus Hagrid's hut brought elements together in a new way. The views from each of these new areas were deliberately chosen to facilitate this. "It allowed you to understand the context of the story for *Azkaban* very well," says Craig, "the relationship of the castle, the back entrance as it were, Hagrid's hut, the landscape, and the Dark Forest. That was unheard of, really."

Set decorator Stephenie McMillan filled the Great Hall with tables and benches, personalized each student's bed and table area in their dormitory, and found huge and comfortable couches and chairs for the four house common rooms. McMillan and her team scoured flea markets and antique shops for props and furniture, in addition to commissioning pieces that proved a bit difficult to find, such as several four hundred-foot-long wooden tables.

Both production designer and set decorator loved that audiences were encouraged to spot the smallest details and even wrestle with the ever-changing continuity of the castle. "They adore it," Craig enthuses. "It's quite fun to do that. But nonetheless I think, by and large, the whole world goes with the spirit of these movies, accepts that the movies are true to the spirit of the books, but [doesn't] unduly mind the changes and the omissions. The omissions you'd think would matter greatly. But people do tend to go with the broad sweep of the thing, the spirit of the whole thing, enjoy the books and the movies and regard them as separate, which indeed they are."

Craig sees Hogwarts castle as a character in the story of Harry Potter. "A rather frustrating character sometimes," he admits. You're trying to bend it to fit a new situation, and it won't always have it." But the school's presence is strong in the story. As strong as Harry's? "Yes, it is," says Craig.

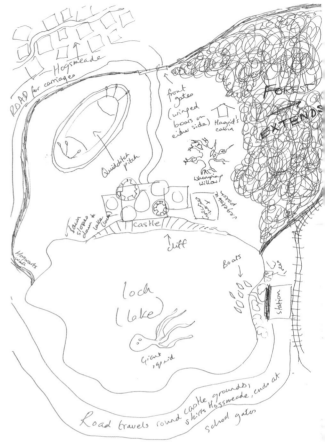

OPPOSITE: *The Hogwarts Express approaches Hogwarts castle in concept art by Andrew Williamson for Harry Potter and the Half-Blood Prince;* TOP RIGHT: *The map of Hogwarts castle and grounds that J. K. Rowling drew during her first meeting with Stuart Craig;* ABOVE: *Concept art by Andrew Williamson for Harry Potter and the Chamber of Secrets.*

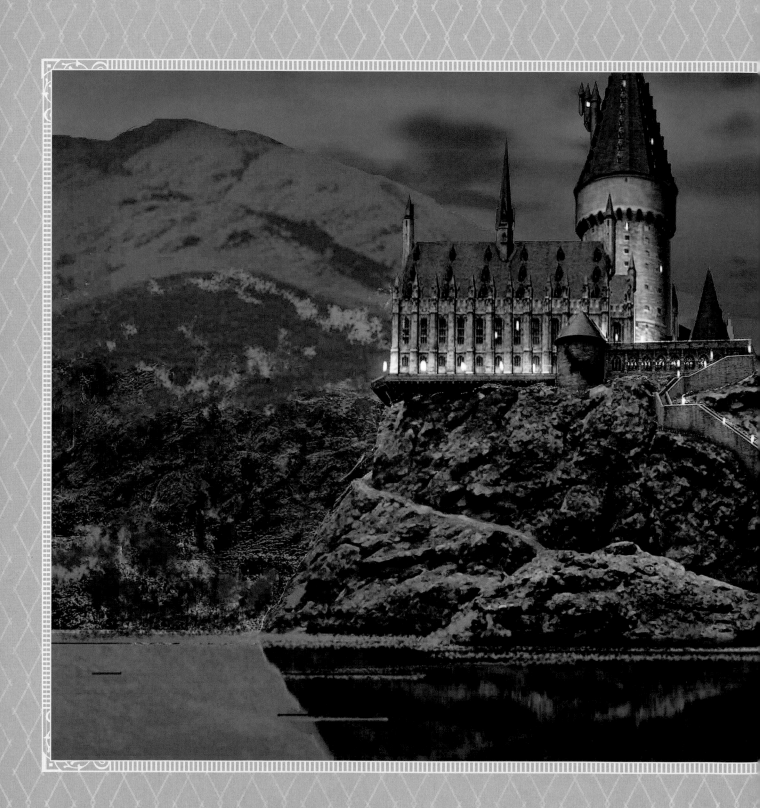

CHAPTER 1

HOGWARTS CASTLE

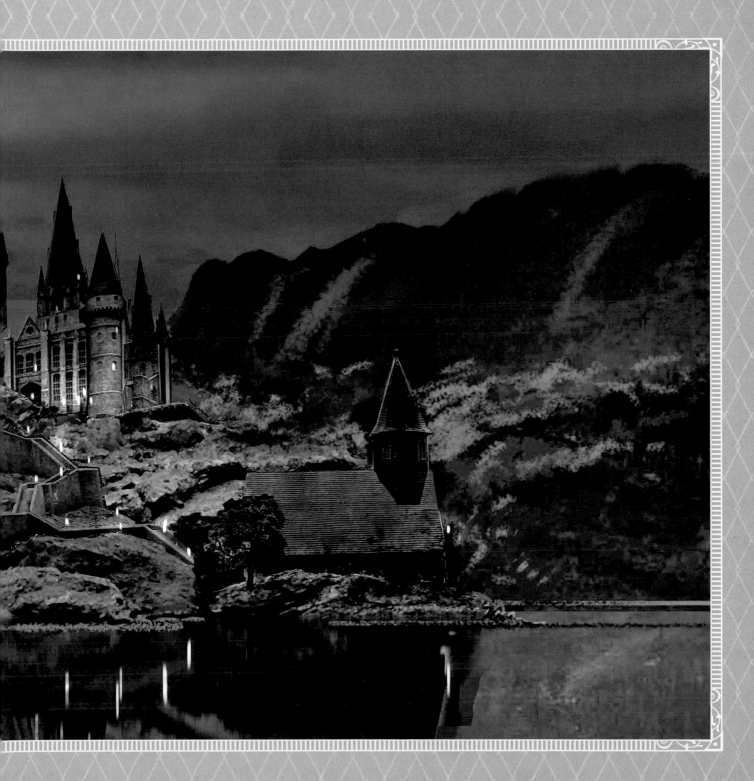

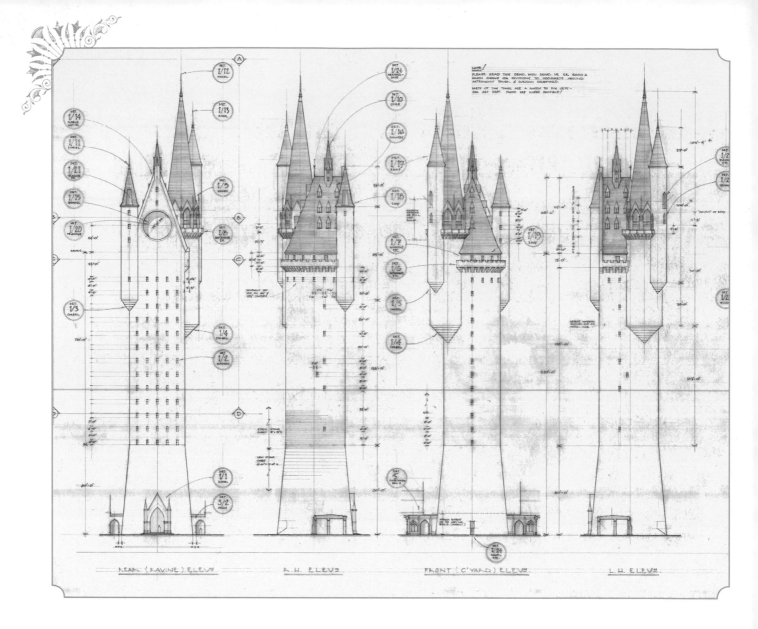

HOGWARTS CASTLE

For production designer Stuart Craig, bringing one of the most iconic locations in one of the most popular, profitable, and influential book series to the screen started with a question. "The first and biggest thing to me was, how old is Hogwarts?" says Craig. "It's suggested to be a thousand years old, a timeless institution, and there are very few examples of architecture in existence that are that old." To find his answers, he first considered the two oldest existing schools in the English-speaking world, Oxford and Cambridge Universities in England. "These are great European Gothic institutions," he explains, "in a style that is strong and dramatic." In fact, four different periods of Gothic architecture helped define the castle's look, in particular an English variety called Perpendicular, which uses strong, vertical lines and large windows supported by elaborate stonework. Craig also

researched the great cathedrals of England, and all these places not only influenced the sets but provided actual locations for shooting. "It was unaffordable and impractical to build the entire castle for the first two films. But as we re-created locations in the studio, we benefited from being obliged to acknowledge the original locations in that the sets are more real. We paid attention to authenticity and architectural detail. For that, the real locations did us a great service, because then we weren't building a world that was completely fantastical or whimsical." Throughout the course of the film series, Craig returned again and again to this underlying design philosophy. "I think magic is made all the stronger when it grows out of something real." Craig visualized this philosophy in a literal way as well. "The castle is made of the rock on which it stands. The castle is an extension of the earth."

PRECEDING PAGES: *Concept art by Andrew Williamson for* Harry Potter and the Half-Blood Prince *shows Hogwarts castle at sunset; ABOVE: A 360-degree blueprint showing the design of the Hogwarts Clock Tower; OPPOSITE: Hogwarts students follow Professor McGonagall into the Great Hall in the first film.*

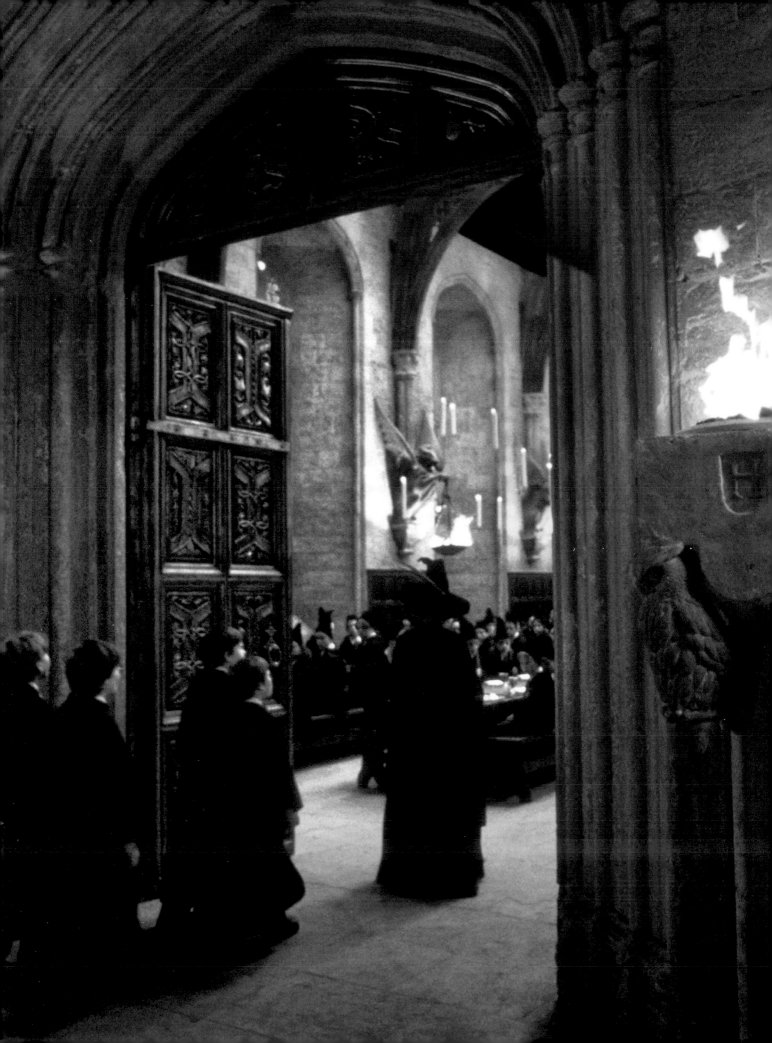

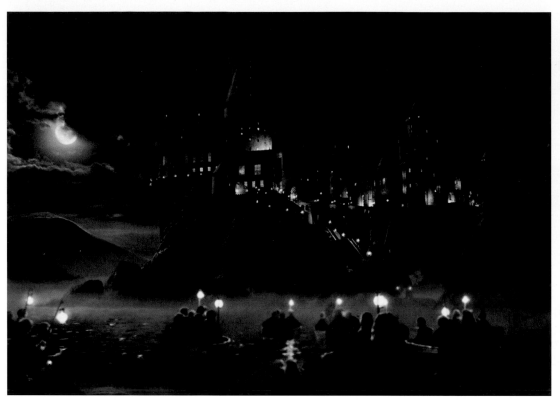

Some sets remained basically unchanged for the entire film series, such as the Great Hall and the Gryffindor common room. "They got a fresh coat of paint a couple of times, but literally stood there for ten years." Additions were added when needed. When Albus Dumbledore's office and a new location for the Defense Against the Dark Arts classroom were needed for *Harry Potter and the Chamber of Secrets*, they were placed in towers that were already part of the Hogwarts' profile. A thin tower was added to hold Sirius Black, Harry's godfather, when he is captured at Hogwarts in *Harry Potter and the Prisoner of Azkaban*. "The way to go would have been to be able to read through all seven books when we started," says Craig with a laugh. "But I think the changes and additions to Hogwarts added a level of interest to the films. I think the spirit was probably more important than continuity jumps between films."

Through eight films and ten years, the face of Hogwarts changed, as does everything as it ages. Craig admits that he was pleased when he had a chance to reshape parts of the castle. One example is the castle's main entrance, which was initially shot under the iconic fan vaulting of Christ Church, a college in Oxford, for *Harry Potter and the Sorcerer's Stone*. "But," says Craig, "for *Harry Potter and the Goblet of Fire*, the students arriving for the Yule Ball needed to arrive at the front door and go straight in. There was no place to do this at Christ Church, so the entrance needed to be reinvented. We hugely reinvented it for the final film because

it was going to become a battlefield. If Voldemort was going to challenge the school and the kids were going to defend it, then it had to be about the main entrance, which didn't have the scale or the seriousness that we needed. So we reinvented the front entrance again, building a massive courtyard based on the cloister at Durham Cathedral, which we'd taken from before." The color palette used throughout the films also changed. "When the kids were younger and the world was more optimistic, the stones in Hogwarts had a warm honey color tone," Craig explains. As the movies got darker, the walls of Hogwarts were also darkened.

Craig continues, "When you look at the profile of Hogwarts in the first film, it's a mixture of different locations. There's a bit of Christ Church, a bit of Durham, a bit of Gloucester Cathedral, a little bit of Alnwick Castle. To me, the original silhouette of the school, which was forced, in a way, to incorporate these places, wasn't as I would have liked. But as the films went on, the chance to improve and strengthen that silhouette offered itself, and I became quite pleased with it. It was always huge and complicated, but it progressively got more elegant."

ABOVE: *Students approach the castle by boat in* Harry Potter and the Sorcerer's Stone; TOP RIGHT: *A view of the hospital ward and Madame Pomfrey's station;* BOTTOM RIGHT: *Concept art by Adam Brockbank depicts an aerial view of Hogwarts in winter for* Harry Potter and the Goblet of Fire.

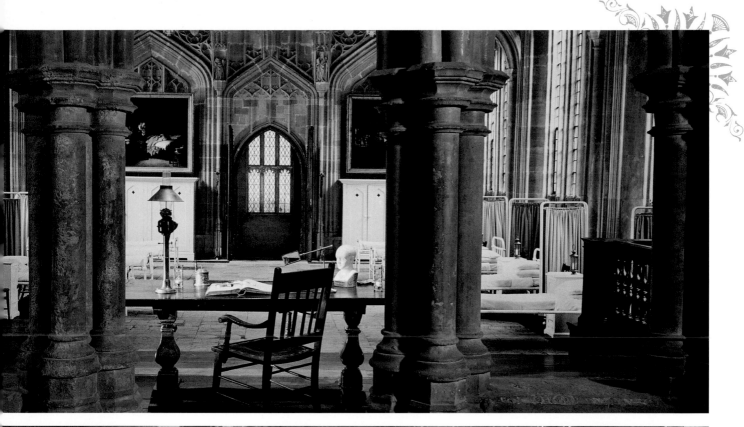

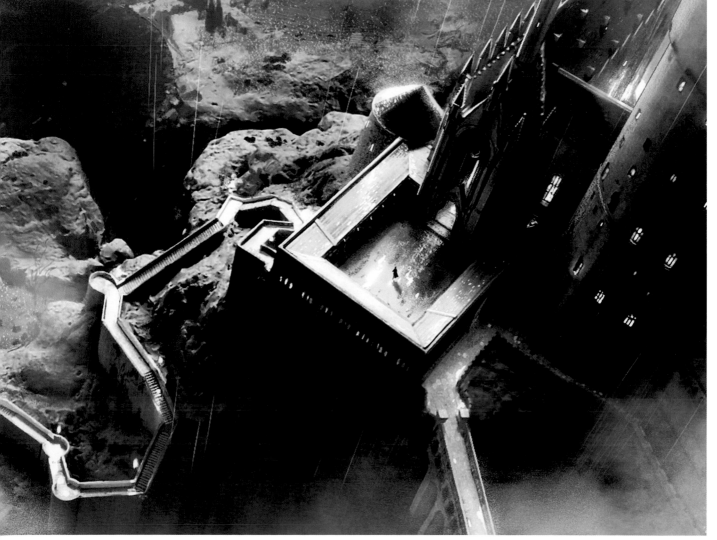

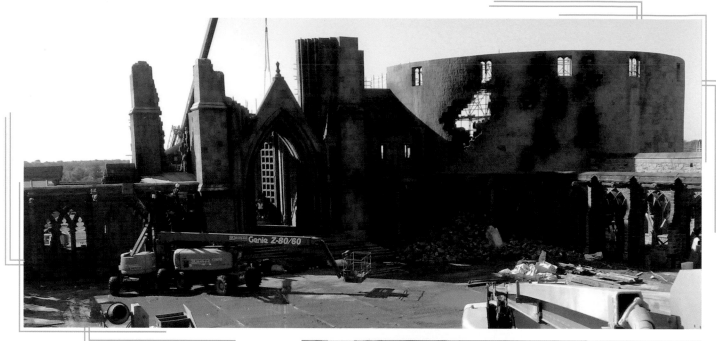

HOGWARTS UNDER SIEGE

Harry Potter and the Deathly Hallows – Part 2 contains the ultimate battle between the population of Hogwarts and Lord Voldemort's Dark Forces, and it showcases the final confrontation between Harry Potter and Voldemort. The destruction of the castle was as important to Stuart Craig as its creation. *Deathly Hallows – Part 2* director David Yates wanted the battle to be large, and so for the final time, driven as always by the story, Hogwarts underwent revision. "We were providing a place for the mother of all battles," says Craig, "so the marble staircase was increased 500 percent. The courtyard was doubled again, and bridges and access ways were added. It was required that statues jump down and take part in the battle, so we needed to change the look of the entrance hall." And he explains that destroying the castle didn't mean just knocking it down. Its ruin needed to be as iconic as its pristine state. "The areas that would be damaged—the Great Hall, the staircases, the roofs—still needed to be recognizable among the shattered stones and charred beams." Practical considerations also came into play. "The scenery is plywood, so if you try to destroy a section, you've just got the raw edges of plywood. You'll just get a

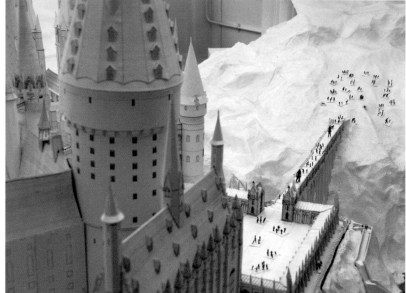

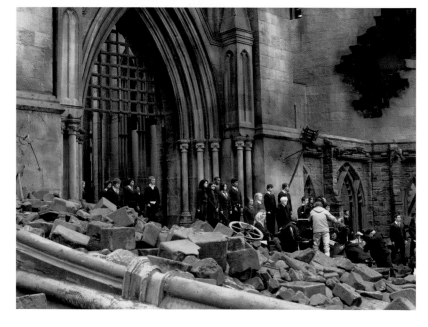

TOP AND RIGHT: *Views from the set of the destroyed Hogwarts castle, in production and during filming;* ABOVE MIDDLE: *A white card model maps out the positions of Hogwarts' defenders and invaders;* OPPOSITE: *Concept art by Andrew Williamson depicts the battle of Hogwarts.*

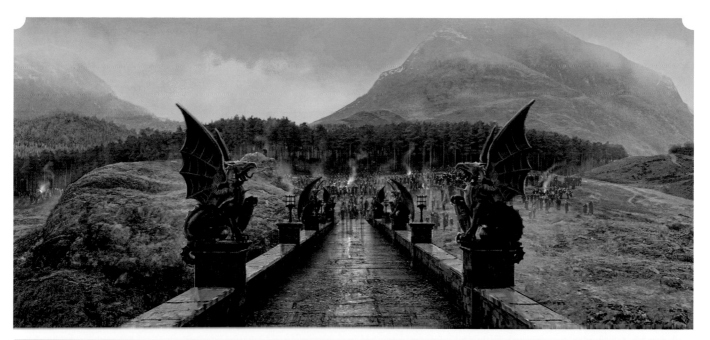

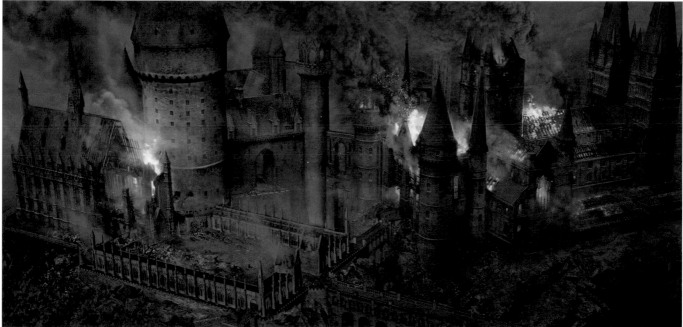

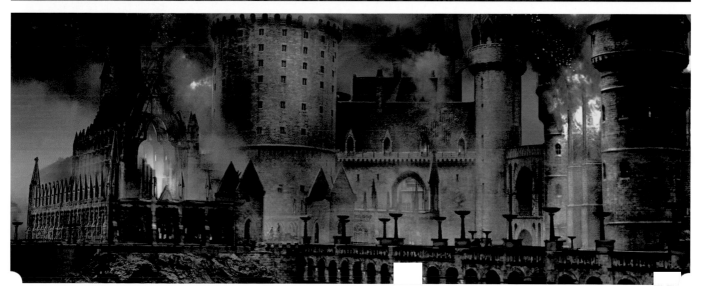

lot of visible Styrofoam and plaster. So the ruins of Hogwarts had to be considered as a new build, not just a taking apart of the old."

To assist in this incredibly challenging task, for the first time Hogwarts was constructed digitally by the visual effects team. "We scanned the model that had evolved from the first film," says senior visual effects supervisor Tim Burke, "which gave us every facet of the building to work with, and then built a destroyed version of the school." Having the model in a digital form gave David Yates the flexibility to make changes or add in new ideas that a practical model would have prevented. As is common in filmmaking, shooting the battle and post-destruction Hogwarts

needed to take place before filming the pre-battle scenes. Property master Barry Wilkinson and his crew created thousands of pieces of rubble in soft polystyrene, including sculpted fragments of Hogwarts' architectural details, which were strewn over the set. "There was a human chain of rubble production for months," says set decorator Stephenie McMillan. After shooting was complete, it was cleaned away. Stuart Craig appreciated the challenge and hard work this set required. "The final standoff between Voldemort and Harry in the ruined courtyard in front of the school with what is essentially the sun rising behind them and the smoke seen through the walls is so emotionally effective."

BELOW: *Harry Potter prepares to battle Voldemort;* OPPOSITE, TOP TO BOTTOM: *Brought to life by Professor McGonagall's spell, the center statue wields a shield with a badger, symbol of Hufflepuff house; Ron and Hermione run down the enlarged marble staircase; the Hogwarts defenders and invaders gather among the ruins in* Harry Potter and the Deathly Hallows – Part 2.

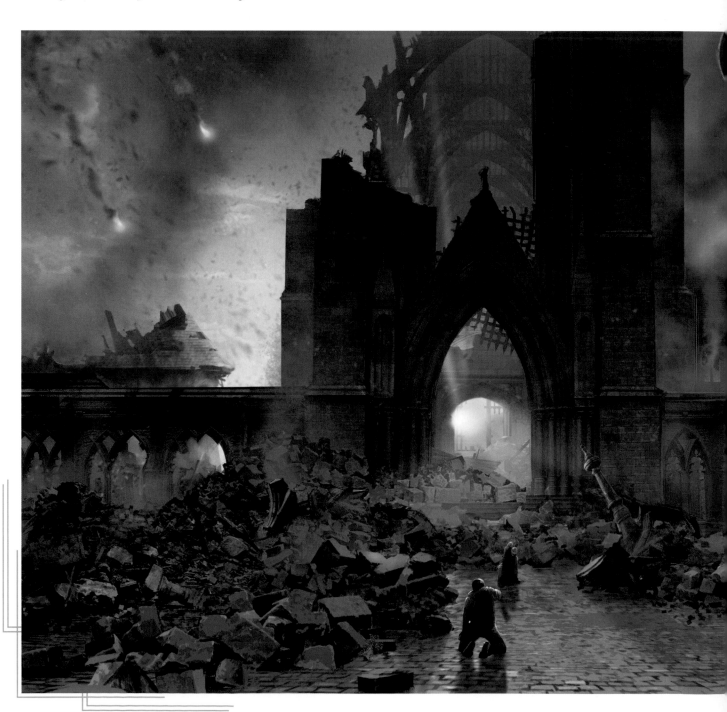

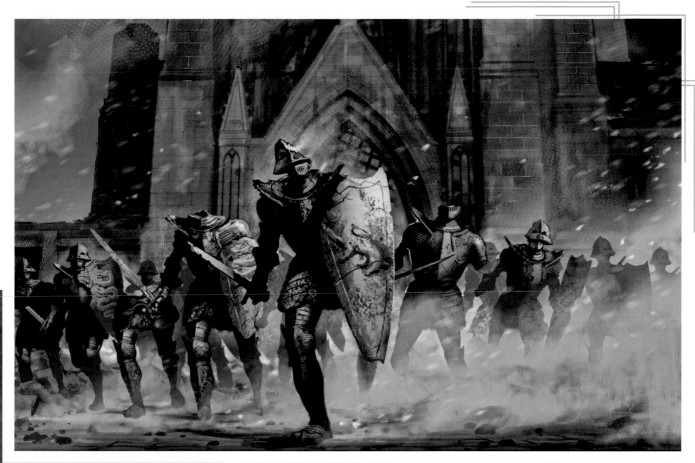

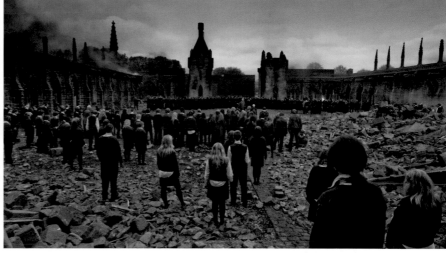

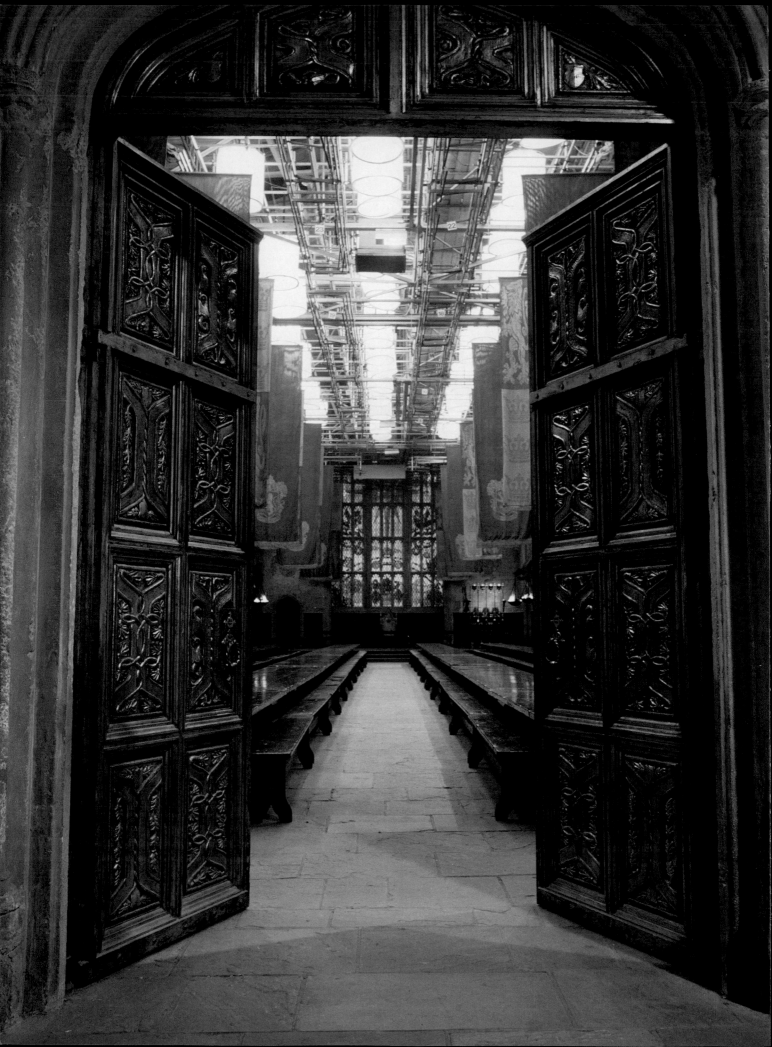

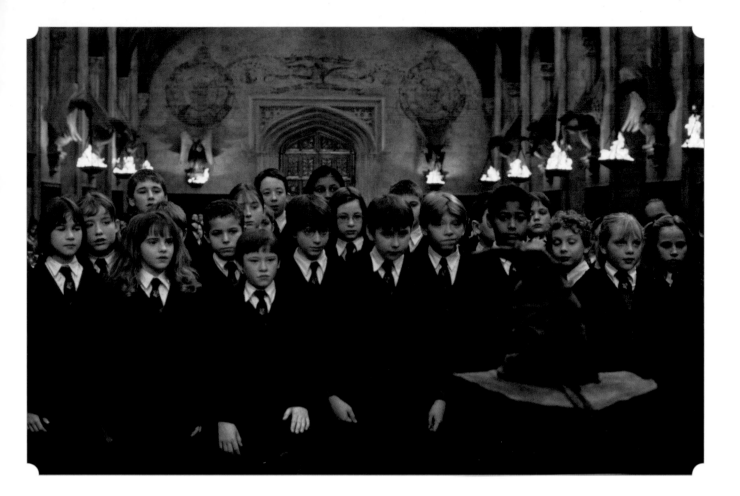

GREAT HALL

"I vividly remember being on the set of the Great Hall when we began shooting *Harry Potter and the Sorcerer's Stone*, so early in the morning," says Chris Columbus, director of the first two Harry Potter films. "It was freezing cold. Leavesden was in its early days as a studio, and the roof leaked. And we could sometimes hear cars and planes outside. But it had a sense of real magic about it."

The Great Hall at Hogwarts is an inspired composite of several renowned buildings in England. The entrance, where the students congregate before the Sorting Ceremony, was filmed on the stairway leading to the Great Hall at Christ Church College, Oxford. Its fan-vaulted ceiling, an architectural style unique to England, is famed for the delicacy of its construction. Hogwarts' Great Hall is based on the same style as Christ Church, keeping the sixteenth-century room's dimensions of 40 feet by 120 feet. It is topped with the fourteenth-century ceiling from Westminster Hall in the Houses of Parliament, replete with hammer-beam style trusses. Then Stuart Craig made alterations to better serve the films. "To me, windows are the most important thing on any set. They're the eyes of the set," he explains. "The windows at Christ Church are very high, and they would have literally been out of the top of the frame most of the time.

So we brought the windowsills down very low, and also added a big oriole window at one end, which is a great dramatic statement and gives the length a focal point." He then let these design choices speak for themselves. "It's really a simple structure, not overcomplicated at all. It has two or three classic features that have stood it in good stead. I think if we'd had too many ideas running in parallel, it would actually have become boring." The most important decision Craig made about the Great Hall set was to install real Yorkstone for the floors. "Although we were told there would be seven books, when we began only the first two novels existed. There was no guarantee that the second movie would be made—not until the first one was a proven success." But he trusted his intuition based on his long filmmaking experience. "If we'd made it in our usual materials, like plaster or fiberglass, the paint would have just worn off," he explains. "Sometimes the fake stuff costs a good deal more in effort and money than getting the real thing." The Yorkstone floor endured through ten years of camera tracks, lighting equipment, and hundreds and hundreds of actors crossing its surface.

OPPOSITE: *The entrance to the set of the Great Hall;* TOP: *First years prepare to be sorted in* Harry Potter and the Sorcerer's Stone.

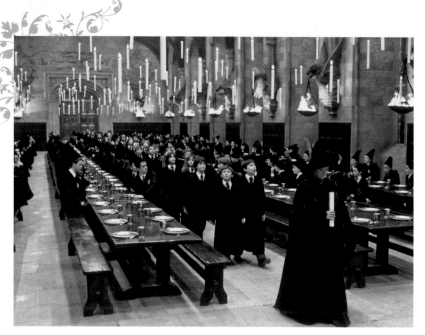

OCCUPANTS:
Hogwarts students, professors, ghosts

SET INSPIRATION:
Modeled on the Great Hall at Christ Church College, Oxford University, Oxfordshire

APPEARANCES:
Harry Potter and the Sorcerer's Stone, Harry Potter and the Chamber of Secrets, Harry Potter and the Prisoner of Azkaban, Harry Potter and the Goblet of Fire, Harry Potter and the Order of the Phoenix, Harry Potter and the Half-Blood Prince, Harry Potter and the Deathly Hallows – Part 2

TOP: *A still from* Harry Potter and the Sorcerer's Stone *shows the floating candles in the Great Hall. After some experimenting, the candles were created digitally for the film;* RIGHT AND OPPOSITE: *Graphics and concept art by Dermot Power illustrate how the celestial night sky might be projected over the sleeping students in* Harry Potter and the Prisoner of Azkaban.

"We built a lot of fire into the Great Hall," says director Chris Columbus, "for it needed to be this magical, warm, loving place." A huge hearth decorated with the Hogwarts crest was placed on one side of the room, and the walls were decorated with flambeaux held by the heraldic creatures that represent the four houses. "Not surprising, though, we were faced with a few challenges. Particularly floating candlesticks and a ceiling that went on forever."

"We had three hundred and seventy real floating candles in the Great Hall," says special effects supervisor John Richardson. "All floating up and down at different times. It looked really magical." Each candle was suspended by two wires and could move up and down. "We had to have a quick way of refilling them," Richardson says. "We had to have a quick way of getting to them and lighting them up and a quick way of putting them out, and we did that." Chris Columbus was in awe of their work: "I remember the very first shot of the Great Hall, where we craned down through all of these floating candles. You couldn't see anything holding them up." But drafts on the Great Hall set blew the candle flames onto the wires. After burning for an hour or so, the flames would cause the wires to break, and the candles would fall, so for practical and safety reasons the floating candles were redone as a special effect. Creating the candles digitally, however, allowed the visual effects artists to arrange them in different patterns, such as circles or tiers, or even add pumpkins during Halloween, throughout the films.

As Hermione Granger tells Harry Potter upon their entrance into the Great Hall, "It's not real, the ceiling. It's just bewitched." Stuart Craig considered several ways to create the ever-changing ceiling view, but he wanted to ensure that it did not look like a two-dimensional painting. Initial thoughts were to treat the ceiling as if it were glass or as if the ceiling itself were made of sky. "We tried to illustrate this, I must say, impossible-sounding idea," Craig says. "In other words, you would see bits of cloud within one of the roof beams. But this would cause great problems for the camera, and it's such an absurd notion that the roof is made of sky that we didn't go terribly far with that." A 1/25th scale model of the ceiling was one part of a film technique used called an "in-camera matte." For this, a camera is aligned perfectly with both the model and the real set being used to create a fully realized location. Then clouds, stars, or rain, along with hammer-beam trusses, were created digitally and composited with this image in post-production.

Digital artists also defined the lower limit of the effect: When rain or snow fell in the Great Hall, it always disappeared on the same horizon line. To show the "real" exterior outside the Great Hall, an enormous hand-painted cyclorama encircled the whole set. "It's a big matte painting of the view from Hogwarts," says Craig, "so that every time you get a glimpse out a window, you see it in the background. This was no static painting, however. When it was supposed to be winter during the films, snow was painted on each of the mountaintops."

Set decorator Stephenie McMillan then filled the space. "We either make, rent, or buy," McMillan explains. "Making the furniture for the Great Hall was obvious because there's nowhere I knew of where you could buy or rent four one-hundred-foot tables and the eight one-hundred-foot benches that go with them!" The tables then needed to be aged as if they had seen many generations of students. To that end, the young actors were never discouraged from carving their names or images into the wood.

actual stars out in the universe

Globe rotates to follow stars as they move through the night sky

Tropicus Capricorni

Pars Iumana

Centaurus
Chiron

Argo Nauis

Crucero

Hydra

HOUSE POINTS HOURGLASSES

Mounted on the wall to the right of the Great Hall's High Table are four large hourglass shaped cylinders representing the houses of the school, respectively in the order of Slytherin, Hufflepuff, Gryffindor, and Ravenclaw. Filled with precious "gems" (emeralds, yellow diamonds, rubies, and sapphires), the hourglasses release these down or back up to indicate points won and lost by the students in each house. Instead of jewels, production designer Stuart Craig loaded the hourglasses with tens of thousands of glass beads, which caused a national shortage of these in England. The hourglasses were fully functional; attention was paid at the beginning of each school year to having the beads occupy only the shorter top portion of the glasses until classes started.

"YOUR TRIUMPHS WILL EARN YOU POINTS. ANY RULE BREAKING, AND YOU WILL LOSE POINTS. AT THE END OF THE YEAR, THE HOUSE WITH THE MOST POINTS IS AWARDED THE HOUSE CUP."

Minerva McGonagall, *Harry Potter and the Sorcerer's Stone*

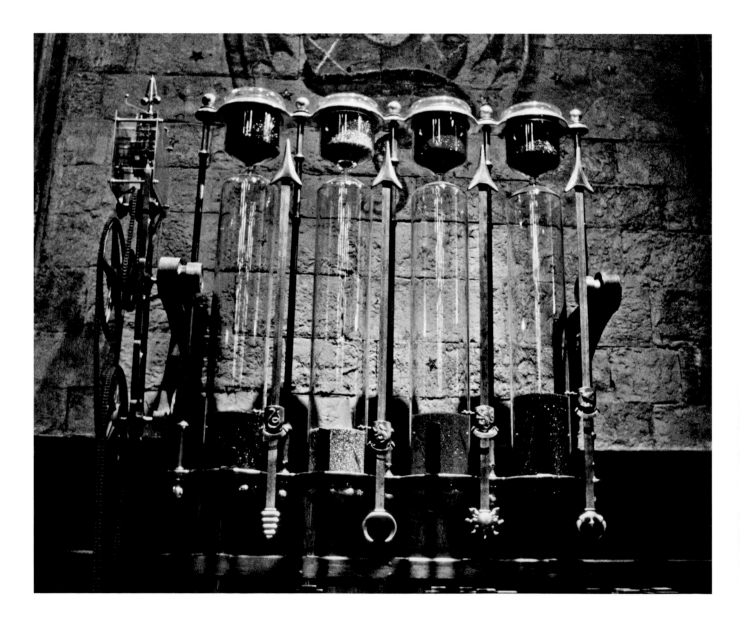

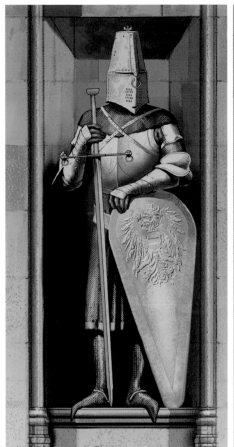

THE FIGHTING KNIGHTS OF HOGWARTS

In *Harry Potter and the Deathly Hallows – Part 2*, the final battle between good and Dark forces—and the final confrontation between Harry Potter and Lord Voldemort—is fought on the grounds and in the hallways of Hogwarts. Teachers, students, and other school personnel are involved, including defenders as yet unseen to this point: the statues of armor-suited knights that are brought to life to protect the school. Jumping down from their perches, they march to battle at the command of Professor McGonagall (who always wanted to use the spell to do that). Concept artists Adam Brockbank and Andrew Williamson drafted knights equipped with chain mail, maces, battleaxes, and shields, several of which show clear allegiance to one of the four Hogwarts houses. One sports a sporran, the leather pouch that is part of traditional Scottish Highland attire, typically worn over a kilt, and another seems better suited to playing in a Quidditch match. The knights came to life thanks to a combination of practical and digital effects. Fiberglass models of the knights were cast and then painted to look like stone. These models were then cyberscanned into the computer for their knightly locomotion.

"PIERTOTUM LOCOMOTOR!"

Minerva McGonagall, *Harry Potter and the Deathly Hallows – Part 2*

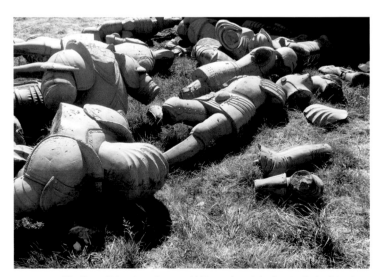

OPPOSITE: *The House Points hourglasses with Ravenclaw right then in the lead for the House Cup;* TOP: *Visual development art of the Fighting Knights by Adam Brockbank featuring individualized weapons and shields;* ABOVE: *Post-battle, the fiberglass versions of the knights lie in pieces on the field.*

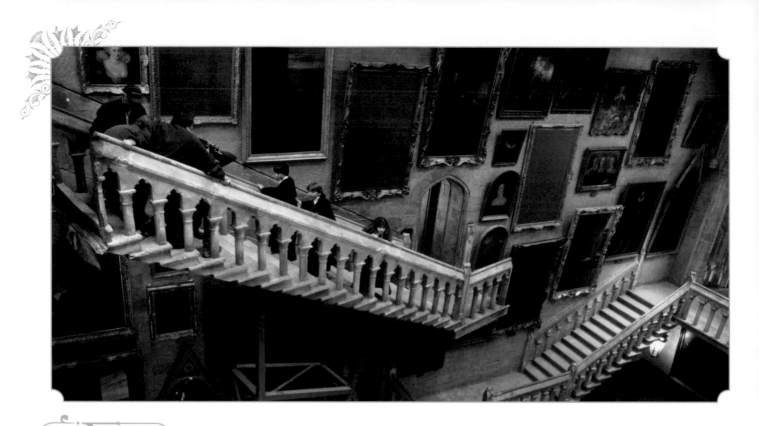

OCCUPANTS:
Hogwarts students,
teachers, paintings

FILMING LOCATION:
Modeled on the staircase
at Christ Church
College, Oxford

APPEARANCES: *Harry
Potter and the Sorcerer's
Stone, Harry Potter and
the Chamber of Secrets,
Harry Potter and the
Prisoner of Azkaban,
Harry Potter and the
Goblet of Fire, Harry
Potter and the Order of
the Phoenix, Harry Potter
and the Half-Blood Prince,
Harry Potter and the
Deathly Hallows – Part 2*

TOP: *Harry, Ron, and
Hermione ascend a staircase
before encountering Fluffy
in* Harry Potter and the
Sorcerer's Stone; *OPPOSITE
TOP: A white card model of
the moving staircases was
used to illustrate the layout
of the portraits; OPPOSITE
BOTTOM: Concept art by
Andrew Williamson for*
Harry Potter and the Order
of the Phoenix.

"OH, AND KEEP AN EYE ON THE STAIRCASES. . . . THEY LIKE TO CHANGE."

Percy Weasley, *Harry Potter and the Sorcerer's Stone*

MOVING STAIRCASES

One of Stuart Craig's first assignments for *Harry Potter and the Sorcerer's Stone* was to install the moving staircases that travel from floor to floor in Hogwarts. To start, he needed to determine how the staircases would move. "When you face a reality of making a staircase move, your options are pretty few," says Craig. An initial thought was to mimic an escalator, but, "as the stairs are made of marble, it seemed too much of a stretch!" He came up with the idea of a staircase literally swinging ninety degrees from one position to the next. "It could be lying against a wall and then swing across space and form a bridge from one landing to another. That seemed the simplest mechanically." He envisioned the complete stairwell as a square made up of staircases on four sides. "Those staircases then led to four sides of another square above, and that led to four sides of another square, and so on. It was like a double helix; the stairs did actually wrap themselves around one another. And somehow this simple module and this simple mechanical move suddenly became a complicated piece of geometry."

Additional inspirations for the design of the moving staircases included a spiral staircase that wrapped around the outside of a building in Reims, France, and the Geometric Staircase in St.

Paul's Cathedral London. "We built our double helix staircase," says Craig, "with blue screen at the bottom, and blue screen at the top. When necessary, it could be extended." The Geometric Staircase, also known as the Dean's Stair, was later used as a shooting location in *Harry Potter and the Prisoner of Azkaban* as the staircase leading up to the Divination Tower, and in *Harry Potter and the Goblet of Fire*, leading down from the Defense Against the Dark Arts classroom. The final look of the moving staircases, when Harry Potter first learns about them, is quite breathtaking.

A moving staircase in *Sorcerer's Stone* is what leads Harry, Ron Weasley, and Hermione Granger to the out-of-bounds third-floor corridor and their first encounter with Fluffy, the three-headed canine guardian of the Sorcerer's Stone. Having the students stand and walk on top of a moving staircase was done as a practical effect. First, Daniel Radcliffe, Rupert Grint, and Emma Watson were filmed in front of a green-screen backdrop on a single staircase that swung to the side via hydraulics. This footage was combined with shots of a highly detailed miniature of the stairwell, landings, and walls that was dressed with hundreds of tiny versions of the paintings.

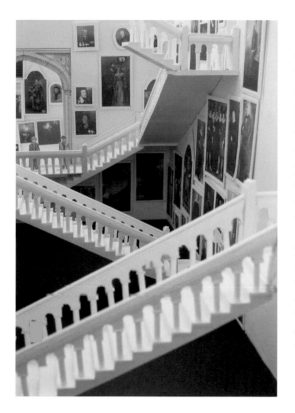

Prior to filming scenes in key locations, the art department would often create white card models for the production team to use—literally small versions of a set or of a location made out of white card—that would be used to plan the actors' movements or camera angles and lighting choices. Placing cutouts of the characters into the sets helped to block (choreograph) the action of each scene. To further assist the director, director of photography, or lighting designer, a tiny camera, called a lipstick camera due to its size, could be inserted into the model to get the right point of view. The white card model was also used in production design to determine the final placement of each portrait. Reference numbers were written on the paintings so they could be repositioned as the scene was planned or if the set needed to be redressed for another scene and then put back into its original configuration. They also ensured that no painting was duplicated on the walls!

As there was frequent interaction between the characters and the portraits featuring moving people or animals, it was important to be able to determine correct eyes lines if the moving portraits were watching the action and especially during contact between character and painting. White card models provided the beginning of figuring out these relationships, which were finalized digitally and utilizing a miniature model of Hogwarts created at 1/25th scale. The model was used to shoot backgrounds that would be composited with the live action to create the final shots.

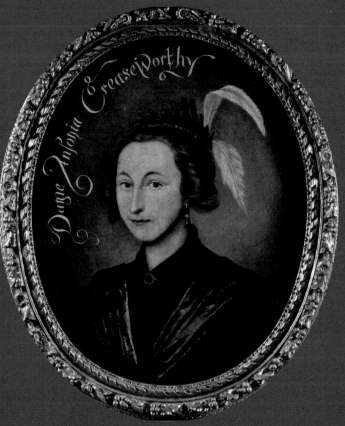

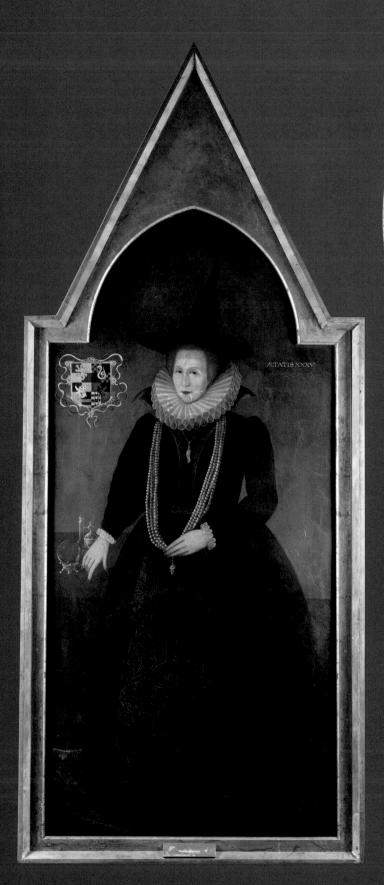

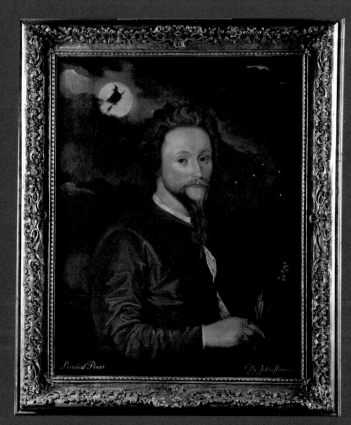

THE PAINTINGS OF HOGWARTS CASTLE

One of the most magical moments on Harry Potter's first day at Hogwarts in *Harry Potter and the Sorcerer's Stone*, which unequivocally signifies an immersion into the wizarding world, is the students' encounter with the moving paintings and portraits on the walls of the grand staircase. Modern technology may have given us video and its own version of moving photos, but there's nothing yet that will top a painting with which you can have an actual conversation. "One of the major tasks of the art director in charge of props," explains set decorator Stephenie McMillan, "was to research and commission the portraits and get them painted." Over the course of the series, Lucinda Thomson, Alex Walker, and Hattie Storey had this responsibility. Their research covered every time period and style. "We looked at the whole history of painting, really," says Stuart Craig, "from classical Egyptian to the twentieth century." Many of the unmoving paintings were based on well-known portraits of royalty or celebrities from literature, art, and society. Creating the artwork involved various processes. "One of our artists, Sally Dray, preferred to paint on a clean white canvas. Very intimating, I think," Craig says. "We would give her the subject, and she would create it from scratch." Others were "cheats." "We would start with a photograph, and the artist would give it a painterly texture, including the appearance of aged varnish, so it would look exactly like an oil painting." Ten artists painted an estimated two hundred portraits for the first film; up to another one hundred and fifty more were added throughout the series to address story points.

For the moving portraits, the same process was followed with a few extra steps. Once the painting was sketched out in concept, the background would be painted and filmed. The moving subjects would then be cast—actors and very often crew members were recruited for the roles. The costume department would create their clothing, set design would coordinate with the props department to put together a setting if needed, and the action would be filmed by the second unit in front of a green screen. Jany Temime, costume designer from *Harry Potter and the Prisoner of Azkaban* through the end of the series, considered this a fun task. "I enjoyed doing the portraits, creating little tableaus of a sixteenth-century wizard or an eighteenth-century wizard. Or we would take a classic painting and 'wizard up' the people in it."

In order to ensure that the portrait's subject had the correct eye line to the actors or action, the scene was first filmed with a green-screen canvas inside the frame. Then the visual effects team would be able to film the actor or actors "in" the painting with the knowledge of where they should be looking. Once all the elements were composited together by the visual effects team, "the moving portrait would be given a texture digitally," explains visual effects producer Emma Norton, "a source of light for shadow or reflection, and often that crackling effect that you get on old oil paintings." One of the visual effects artists' most interesting challenges was to have the digitally added varnish and the brush strokes "done" by the painter shift

Paintings seen on the walls of Hogwarts' Great Hall include: OPPOSITE LEFT: *Elizabeth Burke, who may be a relative of Caractacus Burke, co-founder of Borgin and Burkes;* OPPOSITE TOP RIGHT: *Dame Antonia Creaseworthy;* OPPOSITE BOTTOM RIGHT: *Percival Pratt, who was a well-regarded poet;* RIGHT: *"White card" models were created for consistency of portrait placement.*

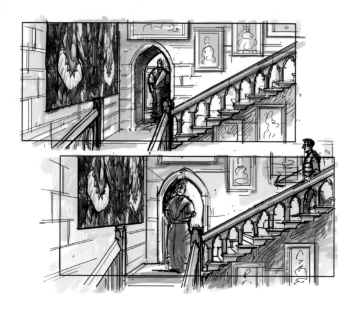

and realign as the portraits' inhabitants moved and talked. Getting the cracked texture to reposition itself was a bit harder than it sounded, but the subtle effect it creates was well worth the time and effort. The final portrait might also be duplicated in a nonmoving form if the painting needed to be in its position on the wall in the background of a scene. As it would be too far away to see distinctly, it wouldn't warrant any motion in it. For scenes on the staircases where there was no interaction between the characters and the portraits, the walls would still be filled with paintings but with only a few that were animated. "You're watching the characters," Norton continues. "You're not looking at the portraits, and you wouldn't want too many moving ones because it would be distracting. There should be a few that could show a reaction to the conversation or the action, but only if they were there to enhance the story, not to be there just because you could put them there."

Another task for the art, props, and costume departments was the classroom for Defense Against the Dark Arts professor Gilderoy Lockhart in *Harry Potter and the Chamber of Secrets*, which featured a large painting of Lockhart painting a portrait of . . . himself. The static inset portrait is reminiscent

TOP LEFT: *Storyboard artwork by Stephen Forrest-Smith for* Harry Potter and the Half-Blood Prince *depicts an unfilmed scene where Harry Potter sneaks past the portraits and out of Hogwarts undetected after having imbibed Felix Felicis;* TOP RIGHT AND OPPOSITE BOTTOM RIGHT: *Unidentified Headmasters;* RIGHT: *Visual development art of Sir Cadogan by Olga Dugina and Andrej Dugin for a moving portrait to be seen in Harry Potter and the Prisoner of Azkaban. Sadly, this brave knight's scenes were left on the cutting-room floor;* OPPOSITE TOP RIGHT: *Professor Armando Dippet, Headmaster when Tom Riddle attended Hogwarts and the Chamber of Secrets was opened;* OPPOSITE TOP AND BOTTOM LEFT: *Newt Scamander, author of the book* Fantastic Beasts and Where to Find Them, *a standard work in the Care of Magical Creatures curriculum.*

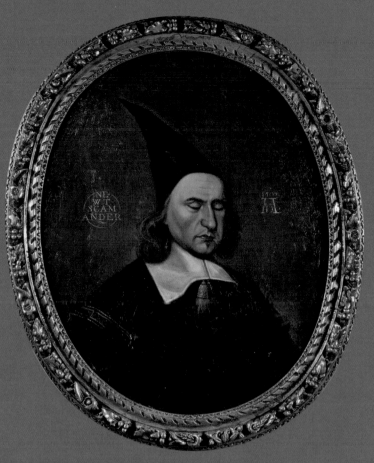

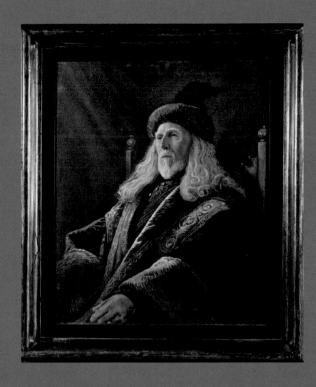

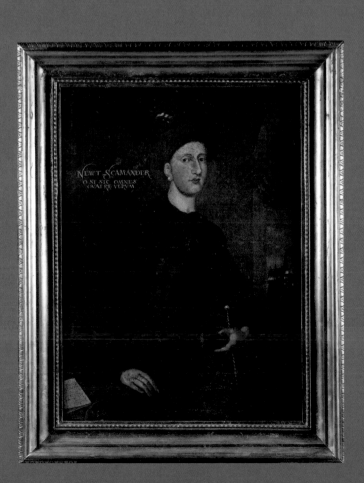

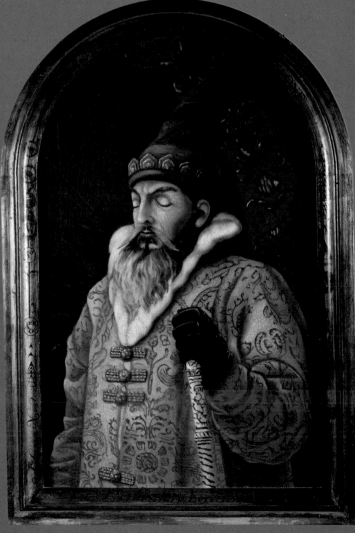

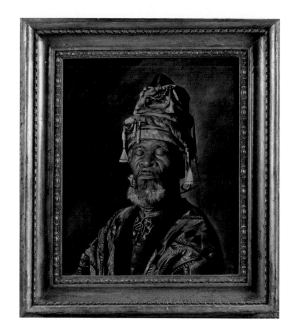

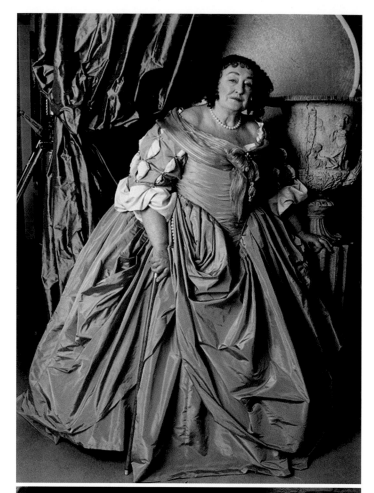

of a 1638 painting by Anthony van Dyck; the larger Lockhart was filmed in the same way as all other moving portraits. Initially, Stuart Craig and Stephenie McMillan proposed that, in a visual effect, Lockhart would walk out of the portrait into the classroom, but eventually it became simply that Lockhart descends down the staircase from his office in a dramatic entrance and only exchanges a wink with his painted double.

In two of the films, many subjects of the paintings leave their frames: in *Harry Potter and the Prisoner of Azkaban* in fear of the possibility of Sirius Black being in the castle, and in *Harry Potter and the Deathly Hallows – Part 2* in fear during the Battle of Hogwarts. "The inspiration for this was a combination of what was in the script and the director's ideas," says McMillan. For *Harry Potter and the Prisoner of Azkaban*, "director Alfonso Cuarón very carefully choreographed all the small ridiculous situations and people running away," she continues. "Then art director Hattie Storey worked with a concept artist to create a master plan for the choreography, according to which various subjects traveled from one portrait to the next." Perspective needed to be attended to carefully. "The movements were very complex," says Emma Norton, "because you were also changing scale. The subjects would be moving through different aspect ratios, and so we'd have

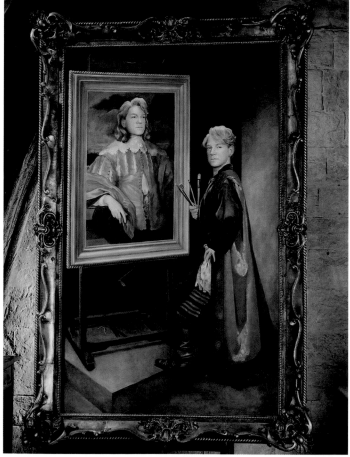

TOP LEFT: *An unidentified Headmaster;* TOP RIGHT: *Actress Elizabeth Spriggs poses for her portrait as the Fat Lady in full costume and with some set dressing for* Harry Potter and the Sorcerer's Stone; RIGHT: *Professor Gilderoy Lockhart paints his own portrait,* Harry Potter and the Chamber of Secrets; OPPOSITE: *The portrait of Professor Albus Dumbledore (Michael Gambon) was placed in the Headmaster's office after the events of* Harry Potter and the Half-Blood Prince.

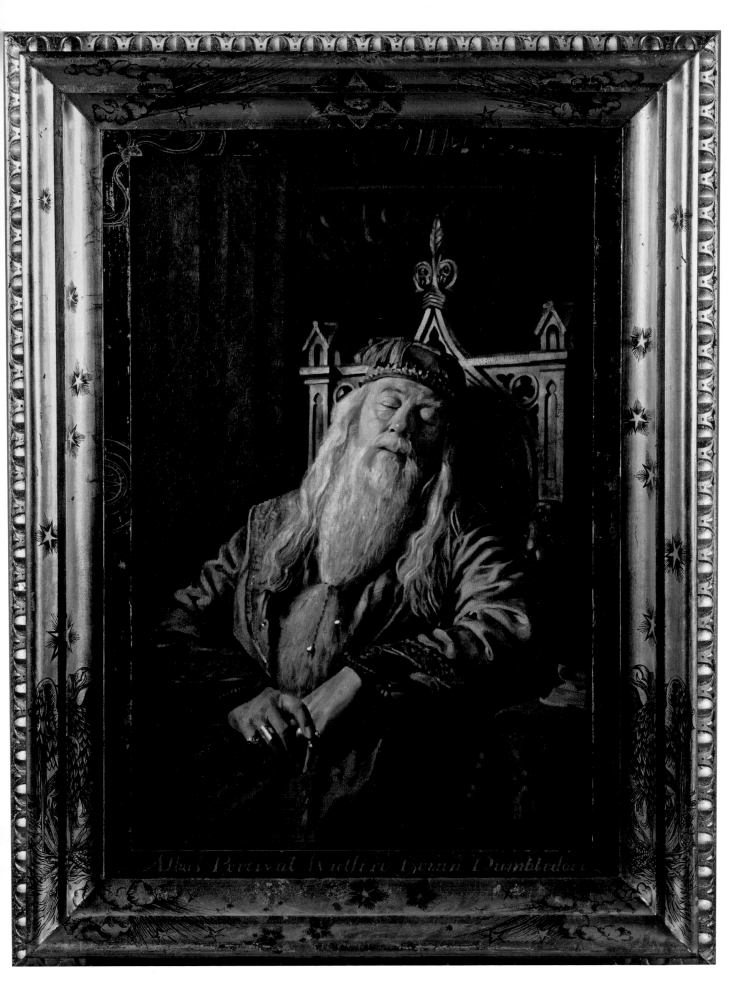

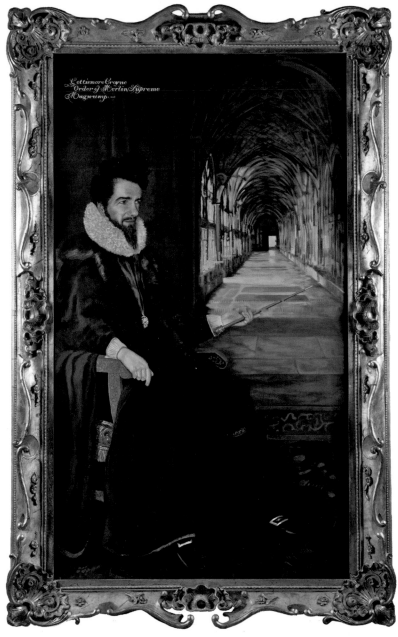

to work out all those cues." The evacuation of the subjects in fifteen of the Hogwarts paintings was a bit simpler in *Deathly Hallows – Part 2*, but still required careful attention to timing as the people and animals fled their frames. Blank and tattered canvases were placed in for the final battle scenes.

In addition to the actors and crew members used as portrait subjects, some of the people "wizarded up" included the films' producers and department heads, as recounted by Stuart Craig: "In Dumbledore's office, prop master Barry Wilkinson's there. Producer David Heyman is on the marble staircase, very prominently, as well as producer David Barron. I'm there. *Harry Potter and the Prisoner of Azkaban* director Alfonso Cuarón's wife and baby are in one, and another features art director Alex Walker. *Harry Potter and the Sorcerer's Stone* director Chris Columbus had his portrait painted, but it didn't make the film. Very good portrait, I have to say." There is a Columbus on the wall of Hogwarts, however. Violet Columbus, the director's daughter, portrays the girl holding flowers who curtseys to the first years in *Harry Potter and the Sorcerer's Stone*.

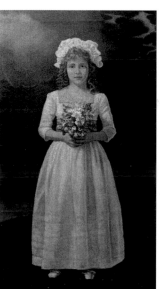

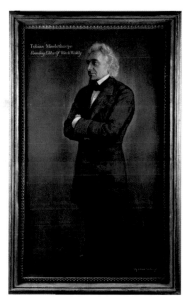

OPPOSITE TOP RIGHT: *A wizard chess match set on the walls of the Gryffindor common room viewed in a deleted scene from* Harry Potter and the Prisoner of Azkaban *demonstrates the coordination of the production design, set decoration, and art departments: The paintings on the wall of this painting are also visible on the walls of Hogwarts, including* OPPOSITE TOP LEFT: *An unidentified witch;* OPPOSITE BOTTOM LEFT AND RIGHT: *Two unidentified Headmasters;* TOP LEFT: *Cottismore Croyne, better known as David Heyman, the producer of the* Harry Potter *films;* TOP RIGHT: *Stuart Craig, production designer for the* Harry Potter *films, is immortalized on the Grand Staircase as Henry Bumblepuft;* FAR LEFT: *The Girl with Flowers was portrayed by Violet Columbus, daughter of director Chris Columbus;* LEFT: *Barry Wilkinson, property master for the* Harry Potter *films, was the model for Tobias Misslethorpe, founder of* Witch Weekly.

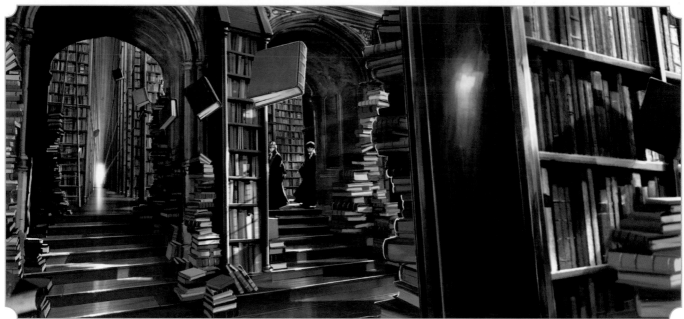

"YOU CAN HELP HARRY, THEN. HE'S GOING TO GO AND LOOK IN THE LIBRARY FOR INFORMATION ON NICOLAS FLAMEL."

Hermione Granger, *Harry Potter and the Sorcerer's Stone*

LIBRARY

During *Harry Potter and the Sorcerer's Stone*, Harry uses his Invisibility Cloak to sneak into the Restricted Section of the Hogwarts library in an attempt to find out more about Nicolas Flamel and the Sorcerer's Stone. For the filming of the library scene, the filmmakers chose to shoot on location in Duke Humfrey's Library, one of forty libraries that comprise the Bodleian Libraries of Oxford University. Duke Humfrey's Library is the oldest reading room at Oxford, dating back to the mid-1400s. "It was a bit of a coup to shoot in the beautiful Bodleian Library," says Stuart Craig. "To even get permission. The restrictions, as you might quite reasonably imagine, were very difficult. And compromises in camera angles happened often, so we decided to build it ourselves for the later films." Duke Humfrey's Library has a system of chaining the oldest books to a frame embedded in the bookshelves, and Craig copied this practice in the re-created version built at Leavesden Studios.

Harry does research in the library to help him in the second task of the Triwizard Tournament in *Harry Potter and the Goblet of Fire*; Hermione observes Romilda Vane flirting with Harry in the library during *Harry Potter and the Half-Blood Prince* while they look for information on Horcruxes. The library books seen in these films were created in different materials for different purposes. "We used a combination of really nice leather books and books that are made out of other materials, like Styrofoam," explains Stephenie McMillan. "Sometimes you have to have books flying through the air! And there are very, very tall piles of books that are part of the library set, so these also needed to be lightweight." In *Half-Blood Prince*, as Hermione and Harry discuss her most recent frustration with Ron Weasley, she carries a stack of books that float out of her hands to their proper places. A simple practical effect was used to shelve the books. As actress Emma Watson held a book out, crew members wearing gloves made of green-screen material would reach through from behind the stacks, take the book, and place it on the shelf. Their hands were then digitally removed from the scene.

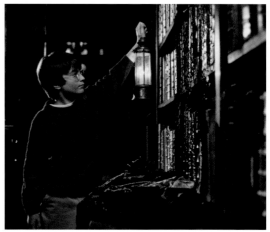

TOP: *Concept art for* Harry Potter and the Goblet of Fire *by Andrew Williamson;* ABOVE: *Harry explores the Restricted Section of the library in* Harry Potter and the Sorcerer's Stone; OPPOSITE: *In a scene from* Harry Potter and the Half-Blood Prince, *crew members wearing green gloves reach out for books. Their hands were later digitally erased.*

OCCUPANTS: Madam Pince, students

FILMING LOCATION: Duke Humfrey's Library, Bodleian Library, Oxford University, Oxfordshire, England; Leavesden Studios

APPEARANCES: *Harry Potter and the Sorcerer's Stone, Harry Potter and the Chamber of Secrets, Harry Potter and the Goblet of Fire, Harry Potter and the Half-Blood Prince*

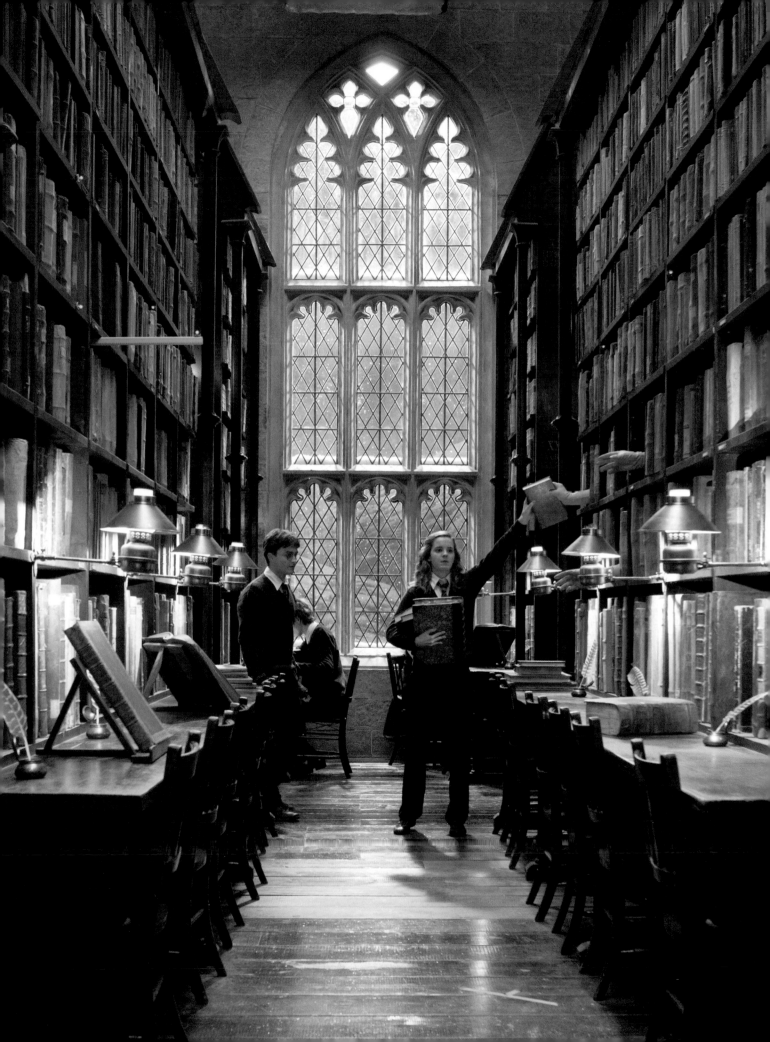

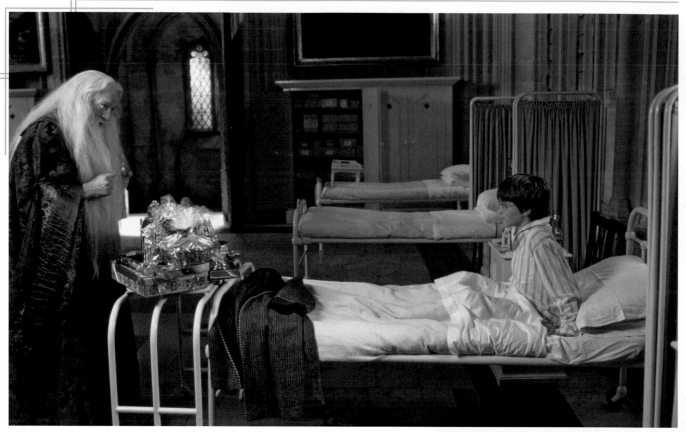

"WE NEED TO GET YOU UP TO THE HOSPITAL WING, SIR, TO MADAM POMFREY."

Harry Potter, *Harry Potter and the Half-Blood Prince*

HOSPITAL WING

Like the scenes in Hogwarts' library, the hospital wing scenes for *Harry Potter and theSorcerer's Stone* and *Harry Potter and the Chamber of Secrets* were filmed in theBodleian Library at Oxford University, this time in the Divinity School. The Divinity School also dates back to the late fifteenth century, and its ceiling is another exquisite example of fan vaulting, this time in the lierne method.

For *Harry Potter and the Prisoner of Azkaban*, the wing was re-created at Leavesden Studios, with a slight restructure. The wing now opened out onto a hallway through which the top half of the Clock Tower pendulum could be seen. Chandelier lighting was also added. Eight beds fill the wing, each with a clipboard at its end that holds the patient's medical information printed on a Hogwarts form, and the medicine cabinets are filled with pill bottles and potions, all labeled by the graphics department. The hospital wing remains unchanged in *Harry Potter and the Half-Blood Prince*; Draco recovers there after he is injured by the *Sectumsempra* Curse cast by Harry, and Ron is brought there after ingesting a love potion meant for Harry.

Sharp eyes will notice that the hospital wing has been converted into the room where Professor McGonagall teaches the Gryffindor students how to dance the waltz prior to the Yule Ball, in *Harry Potter and the Goblet of Fire*.

THESE PAGES, CLOCKWISE FROM TOP LEFT: *A still from* Harry Potter and the Sorcerer's Stone; *Harry and Hermione prepare to use the Time-Turner in* Harry Potter and the Prisoner of Azkaban; *a prop clock; the hospital wing set as it appears in* Harry Potter and the Prisoner of Azkaban.

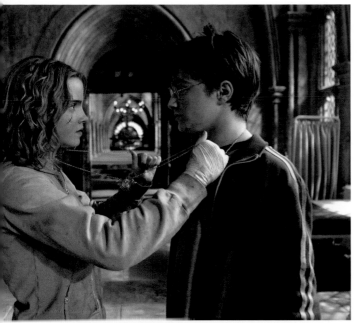

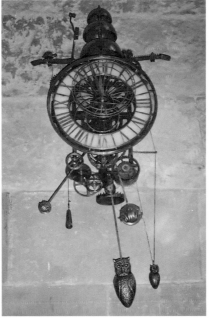

OCCUPANTS:
Madam Pomfrey, ill or injured students

FILMING LOCATION:
Divinity School, Bodleian Library, Oxford University, Oxfordshire, England; Leavesden Studio

APPEARANCES: *Harry Potter and the Sorcerer's Stone, Harry Potter and the Chamber of Secrets, Harry Potter and the Prisoner of Azkaban, Harry Potter and the Half-Blood Prince*

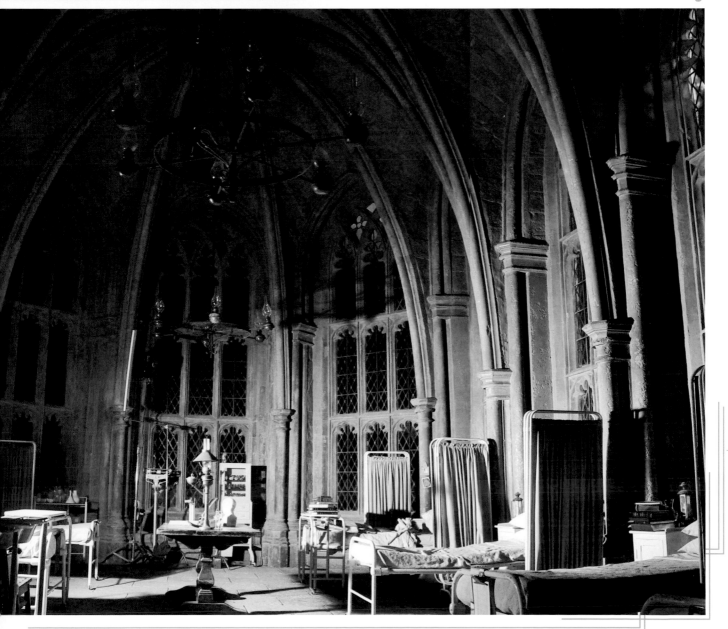

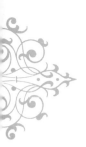

> ## "YOU KNOW THE PREFECTS' BATHROOM ON THE FIFTH FLOOR? IT'S NOT A BAD PLACE FOR A BATH. JUST TAKE YOUR EGG AND MULL THINGS OVER IN THE HOT WATER."
>
> Cedric Diggory, *Harry Potter and the Goblet of Fire*

PREFECTS' BATHROOM

Among Hogwarts' many dramatic backdrops for action, bathrooms are rather prominent—one contains the entrance to the Chamber of Secrets in *Harry Potter and the Chamber of Secrets*, and another is where Harry Potter and Draco Malfoy have their most violent confrontation, in *Harry Potter and the Half-Blood Prince*. The most sumptuous is the Prefects' bathroom in *Goblet of Fire*. As part of the Triwizard Tournament, Harry has to interpret a screeching audio broadcast from a large golden egg to discover vital clues about the second task. His fellow Hogwarts champion, Cedric Diggory, offers an obscure suggestion: that Harry take a bath with the egg in the Prefects' bathroom.

Stuart Craig finds locations like these can fulfill a production designer's dream, as bathrooms contain mirrors and windows. "They're the juicy bits, aren't they?" he says with a laugh. "They're the things that have magic, really. Windows and mirrors, reflected or transparent, give you that layered extra dimension, give you a bit of sparkle. They can be your ultimate weapon." The Prefects' bathroom has three Gothic-arched windows; the middle one features a moving stained glass portrait of a beautiful merperson, designed by conceptual artist Adam Brockbank. She combs her hair while watching Harry and his uninvited guest, the ghost Moaning Myrtle, fathom the second task's clue. The nearly room-size tub is filled via three raised levels of taps, which pour out streams of water, colored blue, red, and yellow. In order to ensure durability, the dozens of taps were sand-cast in bronze.

OCCUPANTS:
Prefects, Harry Potter, Moaning Myrtle

FILMING LOCATION: Leavesden Studios

APPEARANCES: *Harry Potter and the Goblet of Fire*

LEFT: *Concept art by Adam Brockbank shows the stained glass window in the Prefects' bathroom;* RIGHT: *The Prefects' bathroom set as seen in* Harry Potter and the Goblet of Fire.

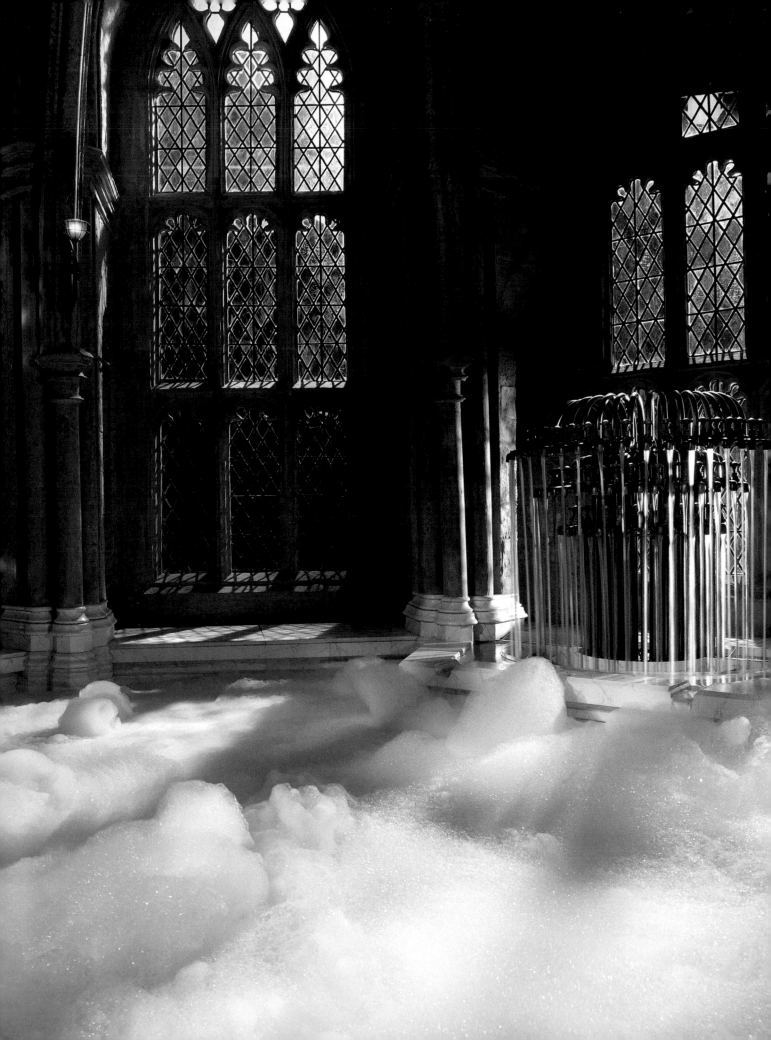

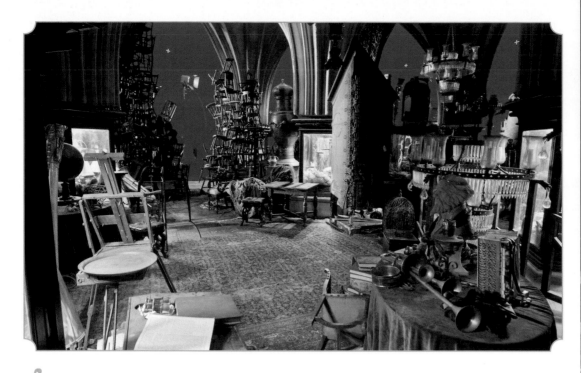

ROOM OF REQUIREMENT

ABOVE: *The Room of Requirement set;* RIGHT: *Concept art by Andrew Williamson depicting the Room of Requirement as it appears in* Harry Potter and the Deathly Hallows – Part 2; BELOW: *Blueprint for the door to the Room of Requirement.*

The elusive, mysterious Room of Requirement first appears in *Harry Potter and the Order of the Phoenix* when Harry Potter needs a place to practice defensive magical arts with Dumbledore's Army, the newly formed group of students prepared to arm themselves against Lord Voldemort. To complement the Gothic style of Hogwarts castle, the Room of Requirement was created with a high, vaulted ceiling whose arches dropped down into columns suspended above the floor. Stuart Craig wanted the emphasis to be on the students, so he did not fill the room as it was described in the books. Craig's "neutral space" was surrounded by mirrors. "I felt that was appropriate in that it reflected the students and their needs back to themselves. And photographically, the reflections offered exciting possibilities." Actor Matthew Lewis (Neville Longbottom) described the set as looking like "an underground fight club in Hogwarts."

Lighting a room encircled by mirrors can be, as Craig admits, "enormously difficult. You not only reflect the camera and the crew, you reflect all the lighting." Craig angled the mirrors and used a dulling spray that eliminated reflections. But a conversation with the director of photography, Sławomir Idziak, offered the most ingenious solution. Craig explains, "We invented an under-floor lighting system, where he could literally light from grilles underneath." The only problem was this also lit the bottoms of people's shoes. The solution: cover everyone's soles with black velvet. Additionally, the crew and anyone walking into the room had to wear blue plastic slippers to keep from treading dust onto the set.

In the films, the Room of Requirement set was sometimes redressed as something else: It became the Trophy Room in *Goblet of Fire*, with glass cabinets supporting the hanging columns, and it was Professor Slughorn's office in *Harry Potter and Half-Blood Prince*, where the dropped columns rested on bases of four Ionic columns. In another "setting," the Room of Requirement was almost seen in plain view of everyone, when graphic designers Miraphora Mina and Eduardo Lima were putting together the Marauder's Map, first seen in *Prisoner of Azkaban*. The pair researched Hogwarts' architecture from the books and original blueprints of the sets in order to show the complicated layers of the school. "But we still made mistakes," remembers Mina. For a long time, the Room of Requirement was part of the design on the map until someone finally spotted it and it was covered over with a new design.

"YOU'VE DONE IT, NEVILLE! YOU'VE FOUND THE ROOM OF REQUIREMENT."

Hermione Granger, *Harry Potter and the Order of the Phoenix*

The Room of Requirement also appears as itself in *Half-Blood Prince*: Harry Potter hides his annotated *Advanced Potion-Making* book there, and the room is where Draco Malfoy places a Vanishing Cabinet, which serves as a passageway to allow Death Eaters into Hogwarts. For this iteration, in which the room is filled with endless piles of abandoned things people have wanted to hide over the centuries, Craig did not want to emphasize the high ceiling. "So the glass cabinets were put back under the columns to support them, and these gave the room a structure that we could then fill with mountains of stuff rising up from the floor, so that the dressing was more dominant." Fortunately, set decorator Stephenie McMillan and the art department, who created and retained the props from all the films, already had a considerable inventory of props to fill the space. Sharp eyes will spot pieces from the wizard's chess set that guarded the Sorcerer's Stone, and the projection machine Snape used in *Prisoner of Azkaban*.

In *Harry Potter and the Deathly Hallows – Part 2*, the Room of Requirement becomes the base for Neville Longbottom and the other students threatened or displaced by Headmaster Snape and his new teachers, the Carrows. The room is stripped down to its bones, populated only by a few pieces of furniture and

hammocks hung from the beams. Once again, the glass cabinets, this time completely empty, support the dropped columns. Later, Harry returns to the Room of Requirement in his search for Ravenclaw's diadem, which has been transformed into one of Voldemort's Horcruxes. Once again, the room appears as a junk pile of abandoned things in one of the final film's most spectacular action sequences. This time, the height of the room was used to its advantage, and Craig and

RIGHT AND BELOW: *Among the many objects stored in the Room of Requirement are the Mirror of Erised and the record player used in Professor Lupin's* Riddikulus *lesson;* OPPOSITE TOP: *Concept art for* Harry Potter and the Deathly Hallows – Part 2 *shows the Room engulfed in flames;* OPPOSITE MIDDLE AND BOTTOM: *Concept art and a preliminary sketch show the room prepared with hammocks for displaced students.*

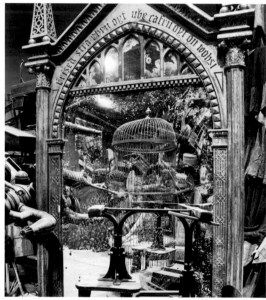

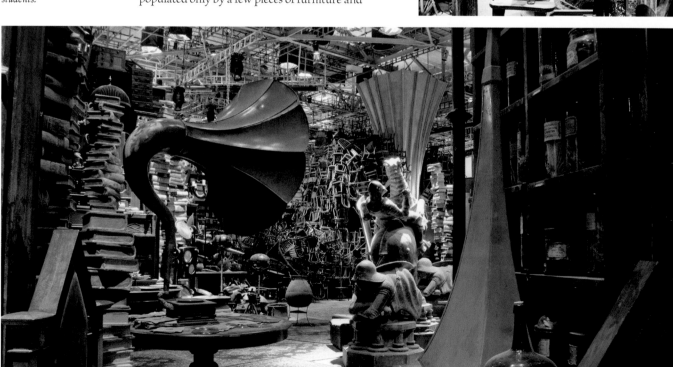

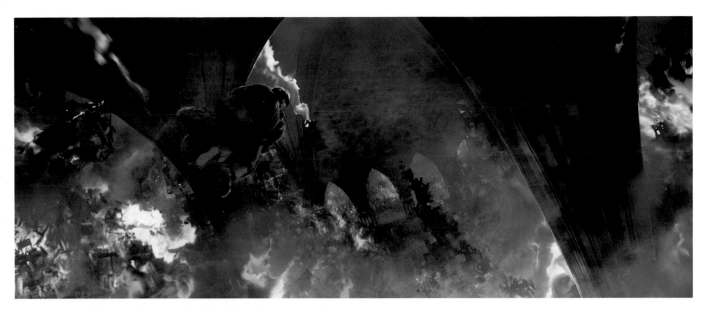

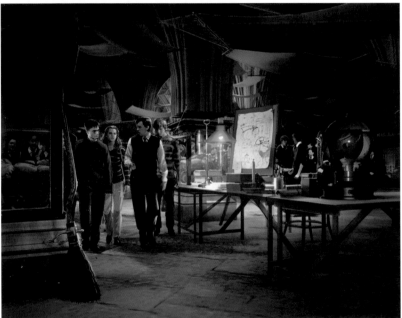

McMillan left no space uncluttered: Craig knew that less wasn't more. "The fact that they were looking for a tiara—this tiny little jewel of an object—in something so massive and complicated just made the task all the more impossible." Craig began "sculpting" the room by fabricating a model out of small Styrofoam blocks, to create what he called its "mountainscape." A bigger model was then made, using doll's house furniture. [Director] David Yates came in to look at the model," recalls Stephenie McMillan, "and said, 'I need another sixty-five feet for them to escape.'"

In preparation to fill the room with the several thousand pieces of furniture necessary, McMillan started buying additional furniture several months prior to shooting the scene. She also used the studio's stock to fill the space and create what she referred to as "the thirteen mountains." Incorporated into the piles was furniture from all the previous films. "We had thirty-six desks," McMillan recounts, "all the tables of the Great Hall, all the benches, all the professors' stools. The trophy cabinet dressing. The chess pieces from the second film. The party dressing from Slughorn's party." McMillan enjoyed walking through the set and seeing these. "And even then, of course," admits Craig, "we cheated and each pile's center was a series of big plywood boxes, just to bulk it up. The furniture was just one or two layers on top of that." Computer-generated imagery extended and filled the room even more. In a stunning scene, Fiendfyre engulfs the room, destroying the artifacts and threatening Harry, Ron, and Hermione inside. Controlled fires were set in the Room, complemented by digitally created flames that resembled a dragon, a snake, and a wolf. Mounting brooms, the trio rescue Draco Malfoy and Blaise Zabini, who teeter atop a tower of burning desks and chairs.

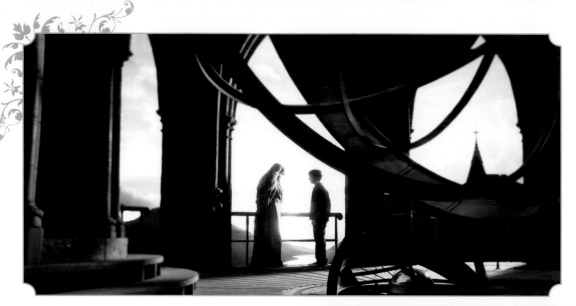

OCCUPANTS:
Hogwarts students
and professors

FILMING LOCATION:
Leavesden Studios

APPEARANCES:
*Harry Potter and the
Half-Blood Prince*

ASTRONOMY TOWER

The Astronomy Tower did not appear on the Hogwarts model used for filming until *Harry Potter and the Half-Blood Prince*, when Harry Potter and Albus Dumbledore Apparate there after retrieving the fake Horcrux locket. Unbeknownst to them, Draco Malfoy has smuggled Death Eaters into Hogwarts, which leads to a confrontation atop the tower and the death of Dumbledore. The Astronomy Tower's set was built with multiple levels, with an upper level constructed with a balcony where Draco fails to carry out his mission to kill Dumbledore. Below this was a lower level where Harry hides from the Death Eaters, although he does run into Severus Snape. "We move things around, let things expand, develop, and disappear altogether," Craig affirms. "So as the series went on, we kept reinventing things, changing things, often because there was a script requirement." On the Hogwarts model for *Half-Blood Prince*, the Astronomy Tower was placed in the same location as the tower where Sirius Black was imprisoned in *Prisoner of Azkaban* (which disappeared from the model after that film).

For Craig, the appearance of the Astronomy Tower was another opportunity to improve the school's silhouette. "The profile of Hogwarts in the first film is a mixture of different locations. Adding the Astronomy Tower was a huge improvement. It's replete with these rather dreamy spires and towers now, and to me a much more satisfactory silhouette with more exaggeration, more theatricality."

The Astronomy Tower, at an estimated 350 feet high, became the tallest tower at Hogwarts castle, but it was also the smallest. "We had seen the interior of it, actually an earlier iteration of a room dedicated to Astronomy," says Craig, referring to the scene in *Harry Potter and the Prisoner of Azkaban* where Professor Lupin teaches Harry the Patronus Charm. "But for this version, it needed

to be impressive. It called for a highly detailed piece of architecture." The Astronomy Tower is actually a composite. "There are towers that are cantilevered off the main tower. So the structure is architecturally very interesting, and although it sits in one space, it's more three spaces melded together." The tower was filled with scientific instruments, mirrors, spheres, and a telescope large enough to sit in, which was one of the most expensive pieces created for the films. In the center of the top level is an enormous model of the solar system, called an armillary sphere, used by the filmmakers to heighten the drama of the scene. Craig's design for the tower echoes that of Dumbledore's office, with a nod to its series of three circles.

THESE PAGES,
CLOCKWISE FROM
TOP LEFT: *Art by Andrew
Williamson shows Dumbledore
and Harry conferring before
leaving to search for Slytherin's
locket; Dumbledore awaits his
fate in* Harry Potter and the
Half-Blood Prince; *Death
Eaters scale the Astronomy
Tower; Harry, Ron, and
Hermione watch Fawkes
depart.*

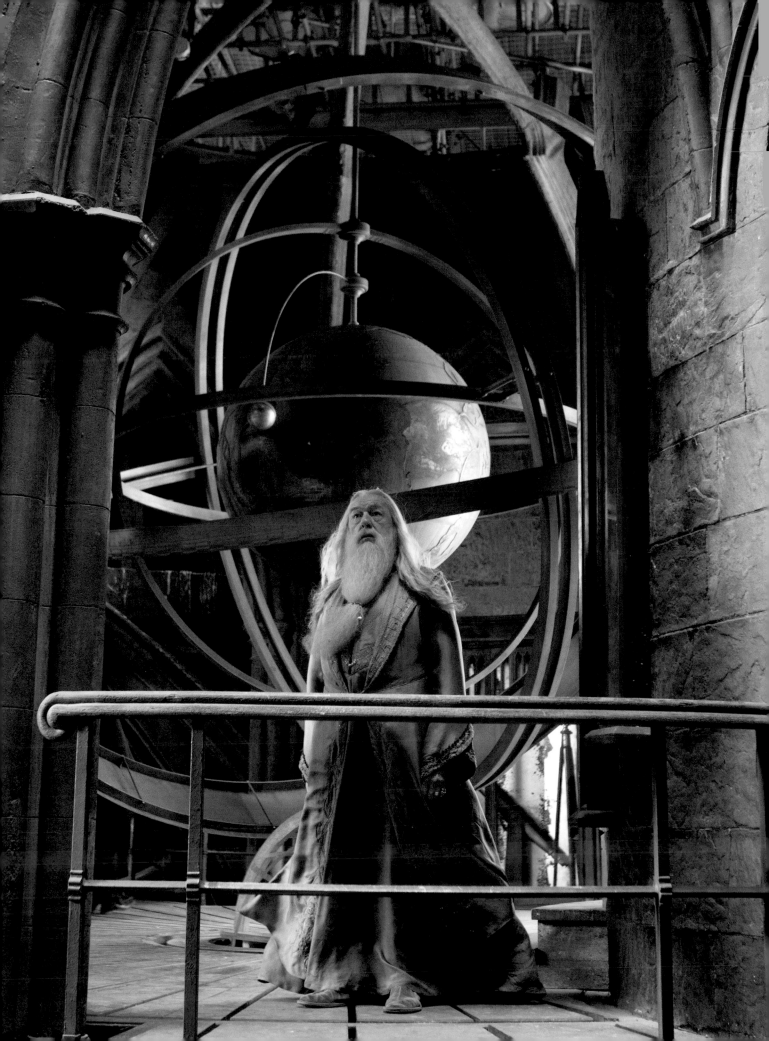

"PASSWORD?"

Fat Lady portrait,
Harry Potter and the Sorcerer's Stone

GRYFFINDOR COMMON ROOM

Stuart Craig wanted the Gryffindor common room to provide "a reassuring feeling of warmth and comfort, with a beat-up sofa [Craig designed the sofa cushions himself], a threadbare carpet, and a massive fireplace." He put a large emphasis on the last item. "The fireplace is significant because Harry has come from this rather unpleasant existence with his aunt and uncle. The common room is the first warm, comforting home experience he's ever had and so the hearth was very important. Then surrounding the fireplace with lush tapestries in a room decorated in rich reds made this place enveloping, almost womblike."

Production design employed a team of researchers that explored the architecture and decoration of various time periods in order to supplement descriptions from the books. The

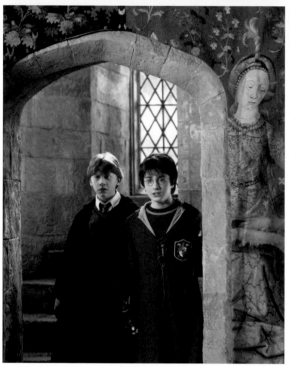

TOP AND RIGHT: *Two stills show the common room's warm contrast to the stone castle;* BELOW AND OPPOSITE: *The Gryffindor common room was one of the few sets that went unchanged throughout the film series.*

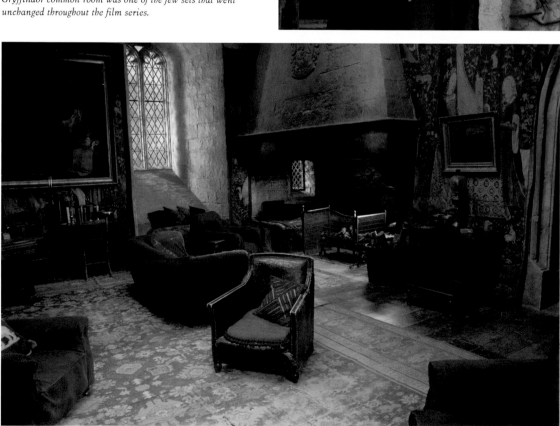

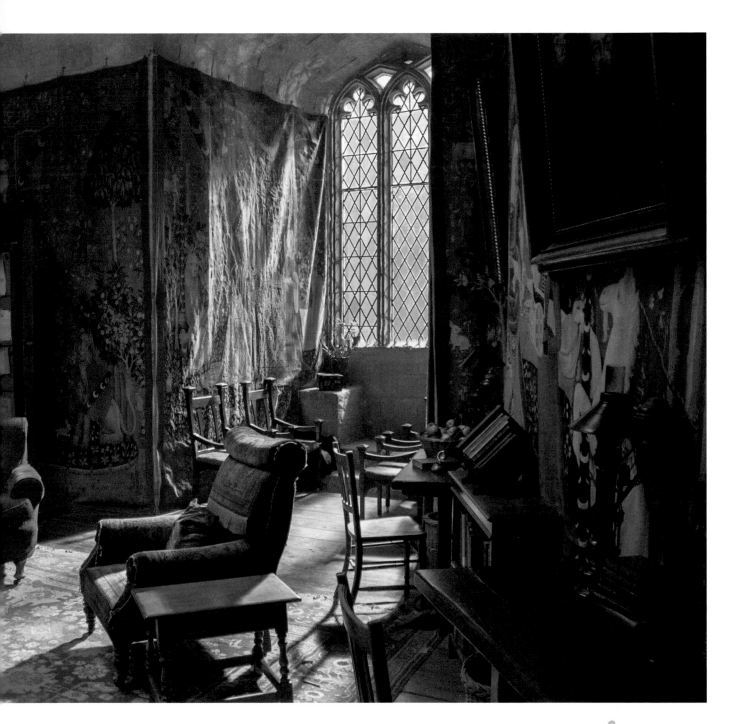

red-and-gold tapestries that decorate the common room were brought to Stuart Craig's attention by researcher Celia Barnett. "She showed me these splendid tapestries with a scarlet background from the Cluny Museum in Paris," he explains, "and the subject of these tapestries is a beautiful French medieval woman and a unicorn. So we asked the museum if we might reproduce them." The museum was happy to oblige, providing transparencies of the fifteenth-century work *The Lady and the Unicorn*, which the design team turned into digital prints.

"With only a few changes," says Stephenie McMillan, "the common room remained the same throughout the films." Announcements on the notice board changed every year, as did timely issues of the *Quibbler* and the *Daily Prophet*, which were scattered around the room. For *Harry Potter and the Prisoner of Azkaban*, director Alfonso Cuarón asked for portraits—some moving—in the common room. "So we painted portraits of past heads of Gryffindor, a small Quidditch match oil painting, and a painting of wizards playing cards." To the right of the spiral staircase that leads to the boys' dormitory is a portrait of young Minerva McGonagall, Head of Gryffindor house. McMillan referred to the common room as "the home base." Near the end of the film series, "when that particular combined set of the common room and the dormitory was struck," she recalls, "it was like, my goodness, our home is gone."

OCCUPANTS:
Gryffindor students

APPEARANCES:
Harry Potter and the Sorcerer's Stone, Harry Potter and the Chamber of Secrets, Harry Potter and the Prisoner of Azkaban, Harry Potter and the Goblet of Fire, Harry Potter and the Order of the Phoenix, Harry Potter and the Half-Blood Prince

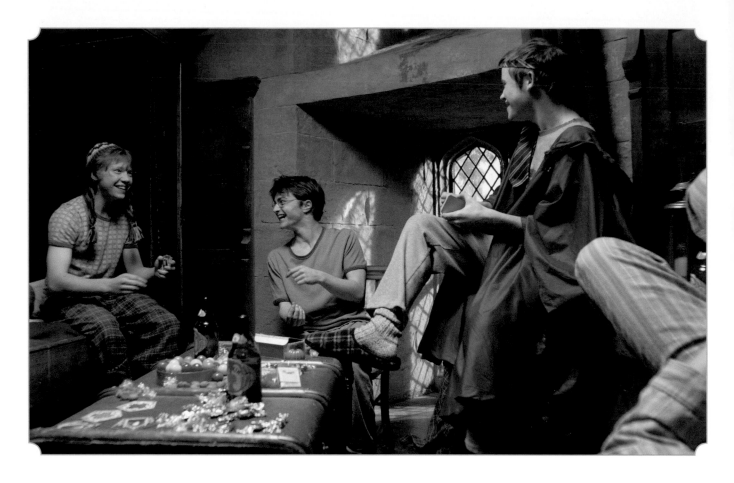

GRYFFINDOR BOYS' DORMITORY

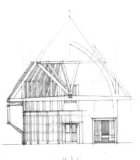

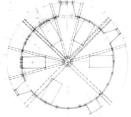

Stuart Craig continued the theme of intimate space in the Gryffindor boys' dormitory. "Harry's lack of security was an aspect of his character that we wanted to explore," he explains, "and in designing the dormitory and his little four-poster bed, we were very conscious of the fact that this was a refuge for him. He felt more at home here than anywhere else, and we deliberately made it small. We draped the beds with curtains because they cocooned him; they made him feel comfortable and safe, which contrasted with the vastness of the rest of the place." The bed frames, with Roman numerals inscribed on top, were stained "a sort of medium to dark oak," says Stephenie McMillan, "which seems to be the standard for English school furniture." McMillan wanted the curtains to be Gryffindor scarlet, of course, and printed with gold magical and astrological symbols and images. She searched antique markets and fabric stores for something to match her idea, but after several weeks of fruitless efforts, McMillan was resigned to creating the fabric for the film. Then, at the eleventh hour, she spotted the very design she desired in a London shop window. Almost. "The design was what I wanted," McMillan says, "but unfortunately, the fabric was purple. Mauve, actually." McMillan

told the shopkeeper she liked the pattern but not the color, and she was about to walk out the door when the woman asked, "What color would you like it to be?" The fabric store was able to provide McMillan with curtain material in the rich scarlet of the Gryffindor house colors.

The cast-iron stove in the middle of the room was by the French manufacturer Godin; McMillan had used it in a previous film. The tables beside the beds were decorated to reflect aspects of each student's interests. Ron Weasley, a devout Chudley Cannons fan, had posters and pennants of his favorite Quidditch team draped around his table, as well as the Quidditch magazine *Seeker Weekly*. Neville Longbottom had books about plants. Seamus Finnigan had shamrocks on his table. For *Harry Potter and the Goblet of Fire*, Seamus "supported the Irish National Quidditch Team," says Stuart Craig, so "we put mementos on his table after the Quidditch World Cup." Teen-related products were created by the graphics department and set on various tables, including Tolipan Blemish Blitzer and Fergus Fungal Budge. Through the course of the films, the actors grew in height, but the beds remained the same size: five feet, nine inches. Clever camera angles hid any feet that hung over the ends of the mattresses when filming.

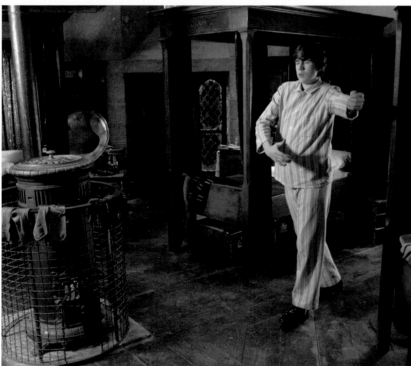

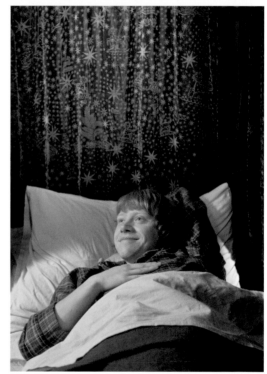

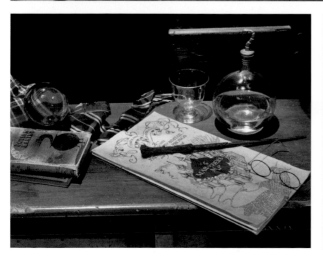

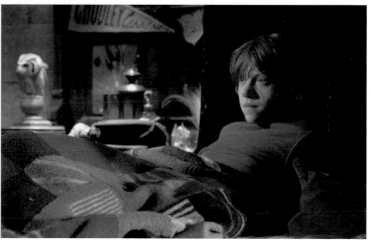

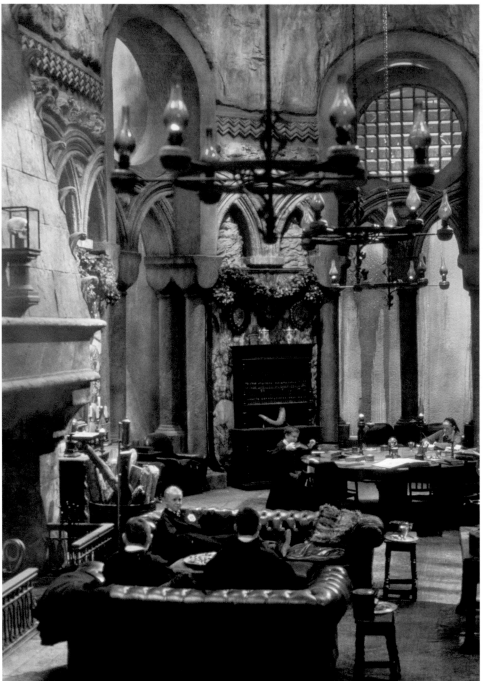

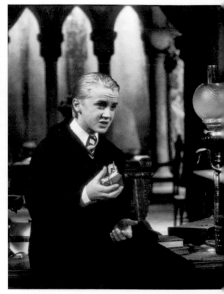

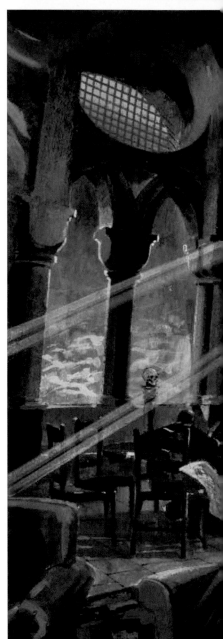

"WE ALSO NEED TO MAKE SURE THAT THE REAL CRABBE AND GOYLE CAN'T BURST IN ON US WHILE WE'RE INTERROGATING MALFOY."

Hermione Granger, *Harry Potter and the Chamber of Secrets*

ABOVE: *Harry and Ron use Polyjuice Potion to disguise themselves as Crabbe and Goyle in order to question Draco Malfoy (top right);* RIGHT: *Art by Andrew Williamson shows light refracted by lake water entering the Slytherin common room.*

SLYTHERIN COMMON ROOM

In *Harry Potter and the Chamber of Secrets*, the common room used by Slytherin Draco Malfoy and his cohorts Crabbe and Goyle contrasts in every way with its Gryffindor counterpart. Unlike the airy tower that accommodates Gryffindor students, Slytherin's cavernous common room is situated under the lake. Stuart Craig wanted a stockier, sturdier feel to it, "as if it was carved out of solid rock." Inspired by Jordan's Petra Treasury, the room was constructed with no blocks or joints in its masonry. Craig chose an earlier style of architecture than in the rest of the castle. "It's more Norman or Romanesque, so there's a slightly different feel about it, although I think this is perceived subconsciously." The silver-and-green Slytherin colors provided Stephenie McMillan with her palette for the tall, dungeon-like room. "We had black leather sofas, and tapestries on the walls with all the red taken out, so they were printed with more green and blue." This also added to the room's underwater feel. The ornaments and decorations were crafted in silver and featured serpentine designs. While the fireplace is as large, if not larger, than Gryffindor's, there is no fire lit; it is cold and dark.

OCCUPANTS:
Slytherin students

FILMING LOCATION:
Leavesden Studios

APPEARANCE:
Harry Potter and the Chamber of Secrets

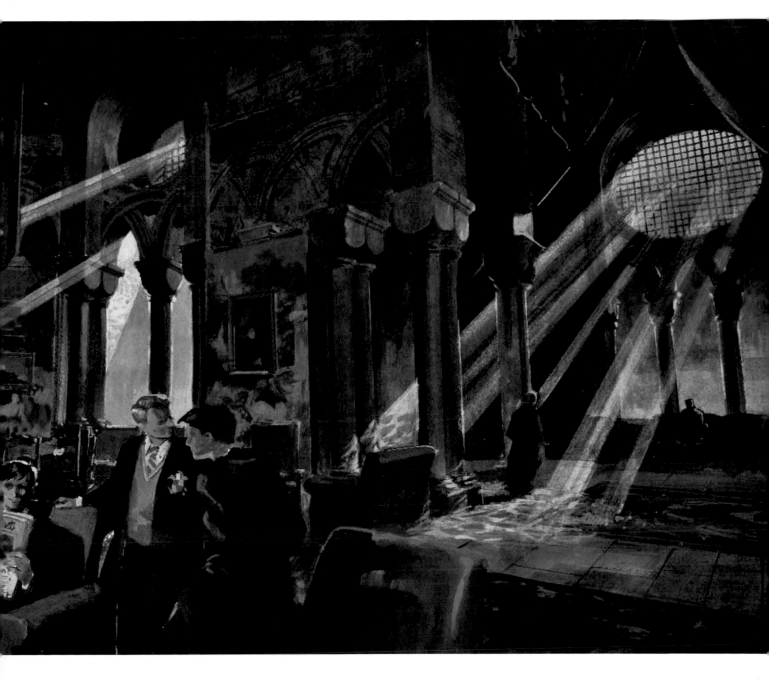

CHAPTER 2

HOGWARTS GROUNDS

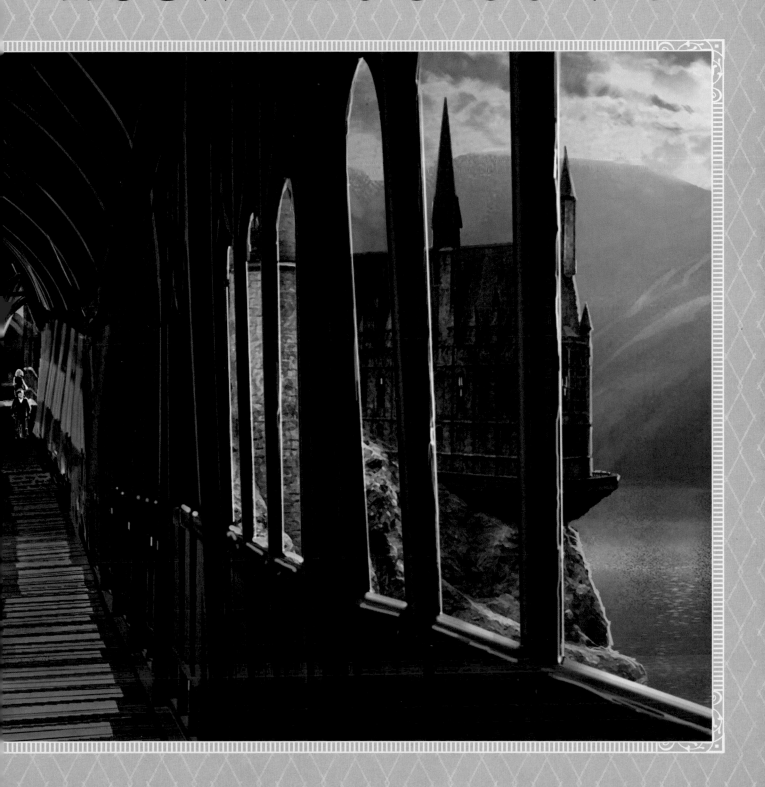

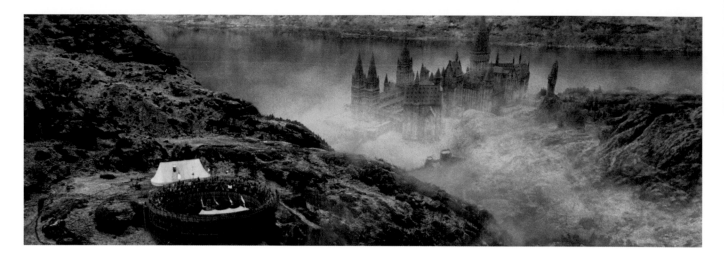

HOGWARTS GROUNDS

Surrounding Hogwarts castle is a long, quiet lake; a dark, unfriendly forest; deep valleys; and soaring mountains. "J. K. Rowling never actually says that Hogwarts is in Scotland," says production designer Stuart Craig. "But we worked it out pretty quickly that that's probably where we should be looking for the backgrounds to the films. Some of the most dramatic landscapes in these islands are the Highlands of Scotland. So we went there and asked, what's the *most* dramatic, iconic place? It's Glencoe, which is the highest pass in Scotland. The mountains are sensational. The valley and the rivers that run through it are beautiful. In our Highland exploration, we found Loch Shiel and Rannoch Moor and Fort William." He searched these and other locations in Scotland with location manager Keith Hatcher. Craig explains, "It gave a sense of where the world should be. We did spread the net wider in an effort just to prove, really, that our first choice was right. But that question was quickly settled."

The second unit crew made several trips up north prior to shooting *Harry Potter and the Sorcerer's Stone* to photograph these locations for establishing shots or background shots. And in a time-honored movie tradition, the sites were manipulated to serve the story. "All the best elements in Scotland," says Craig, "are not remotely together; we forced them together. There were Scottish lochs where there were no lochs, and mountains where there were no mountains. We made this idealized, beautiful, dramatic landscape out of all these different places."

Harry Potter and the Prisoner of Azkaban required a considerable amount of exterior shooting, so for the first time, the cast and crew went to Scotland with the first unit and shot in various locations. "Hogwarts should be in the Scottish Highlands," says Alfonso Cuarón, the director of *Prisoner of Azkaban*. "You needed to have the sense of the hills, not the flatness that you find in locations around London. We went to Scotland for three weeks to shoot in the environment around the castle. That was important, and something that Stuart Craig fought for. He found the most amazing locations to make everything happen." For a movie of this size and complexity, with young actors who required teachers and chaperones, it was a major undertaking. "And it rained, and it rained, and it rained," Craig recalls, "which added time and cost to the film."

The filmmakers never went on location as extensively as that again, but they did continue to send the second unit to Scotland to shoot backgrounds, which were composited with scenes shot in the studio, surrounded by green screen. The filmmakers regularly pulled from this digital database of location photography and film footage. "We cherry-picked all," Craig affirms. "The best loch, the most photogenic mountain pass, the best valleys and forests, and slammed all these things together. And we ended up with a pretty powerful set of images."

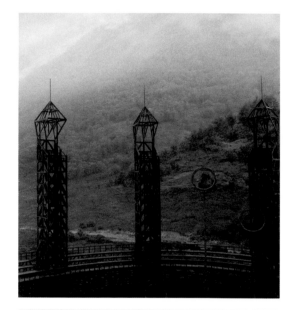

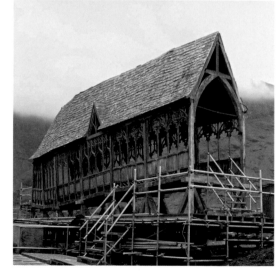

THESE PAGES, CLOCKWISE FROM TOP LEFT: *The final composited image of the arena used in the first task of the Triwizard Tournament; a visualization used in the development of the bridge built for the third Harry Potter film; Hagrid's hut in* Harry Potter and the Prisoner of Azkaban; *construction of the Hogwarts covered bridge was started well before the filming of* Harry Potter and the Prisoner of Azkaban; *the Quidditch pitch, as seen in* Harry Potter and the Half-Blood Prince.

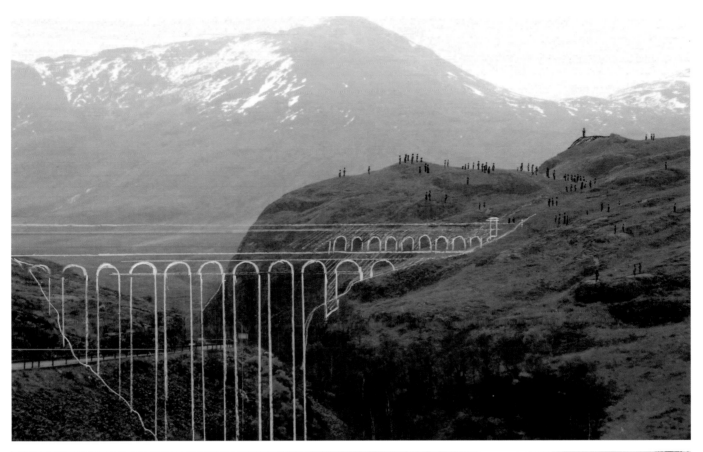

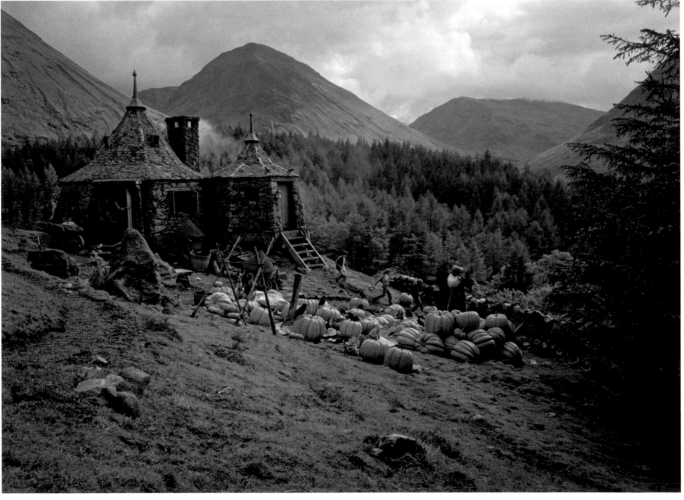

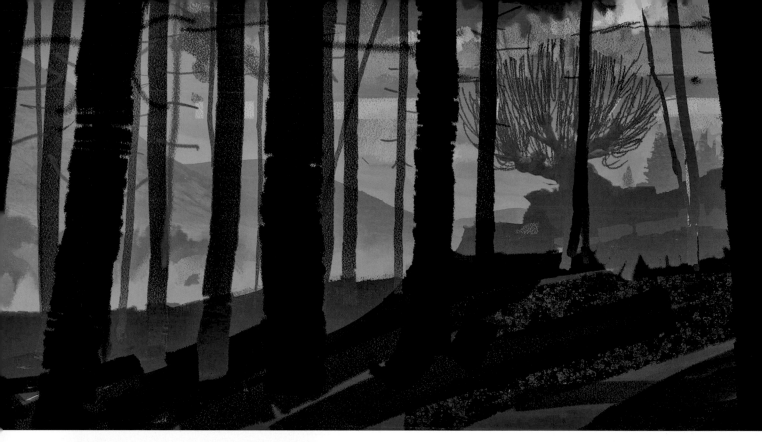

FORBIDDEN FOREST

Whether it is called the Dark Forest or the Forbidden Forest, Stuart Craig considers the forest in the Harry Potter films a character in itself. For *Harry Potter and the Sorcerer's Stone*, the first forest scenes were filmed on location in Black Park in Buckinghamshire, England. However, for the scene where Harry encounters the centaur Firenze, the forest was a built set, and from then on, except for part of *Goblet of Fire*, the Forbidden Forest was a studio creation.

For *Harry Potter and the Chamber of Secrets*, the forest "became more fantastical. It was based on truth, but it was an exaggeration of truth, so the tree forms, the root forms, and even Aragog and the Acromantula in their lair were very real, but their size was hugely exaggerated." Craig's intention was that as one went farther into the forest, it got bigger in scale, more theatrical, and more creepy and frightening. "It's relatively recognizably normal on the outside, and the deeper you penetrate it, the bigger it gets. More intimidating and mysterious. Even the mist gets thicker." The Forest was built at Shepperton Studios, with a real frozen lake in it, for *Harry Potter and the Prisoner of Azkaban*.

Craig was challenged once again for the forest scenes in *Harry Potter and the Order of the Phoenix*. "We always think, how can we develop this forest idea? How can we make it more interesting this time?" He looked back to Aragog's lair in *Chamber of Secrets* for inspiration, particularly the sheltering trees' massive roots. "So I took those roots and made them bigger again, rethinking the shape." He thought of mangrove swamps and how mangrove trees are perched on their root systems. "It almost looks as if the trunk is being supported by fingers, which was a great profile. Mangroves are relatively small, however, and so we made the trees twelve to fourteen feet around. Bigger even than the redwoods in Northern California." The textured surface of the trees was first painted with a warm brown base color, then a darker brown was sponge-rolled onto its "bark." Dry brush painting techniques were used to "floss" the trees, which adds highlights. A spray of paint and water blended the colors, and finally, artificial moss and lichen made of colored

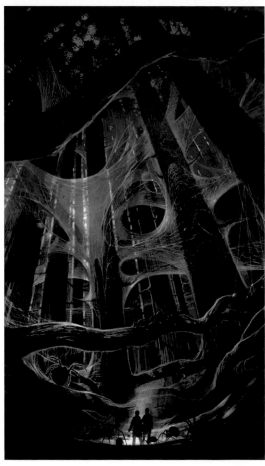

TOP: *A view of the Whomping Willow from between the trees of the Forbidden Forest;* ABOVE AND OPPOSITE BOTTOM: *In art by Dermot Power, Harry, Ron, and Fang enter into Aragog's webbed lair.*

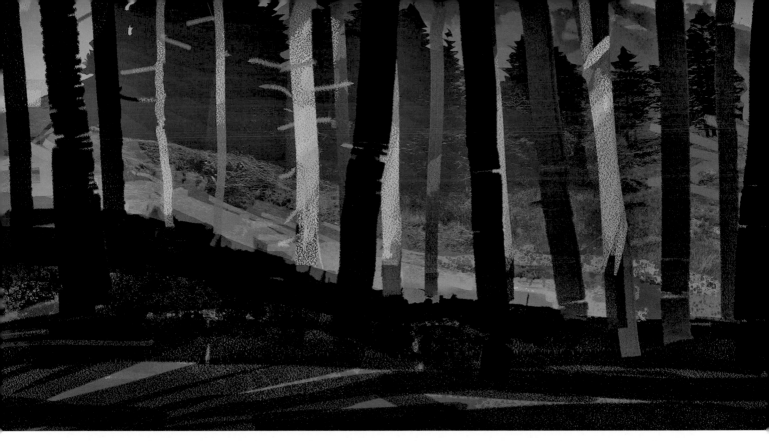

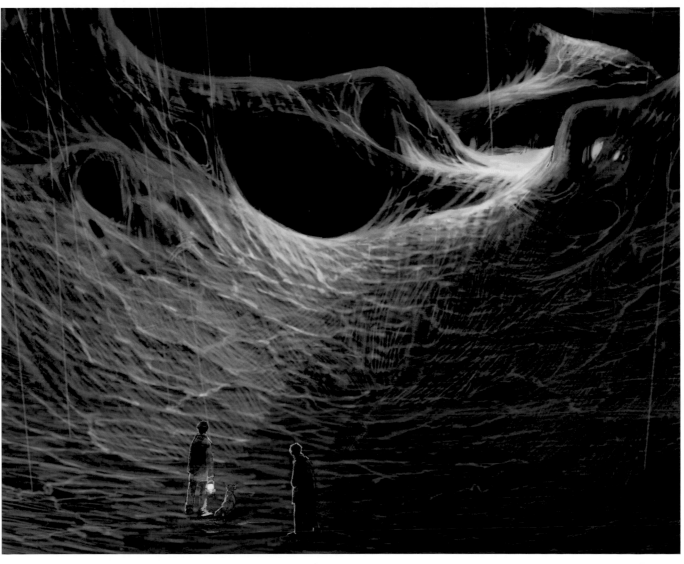

OCCUPANTS: Centaurs, unicorns, Acromantula, other creatures

FILMING LOCATION: Black Park, Buckinghamshire, England; Frithsden Beeches Wood, Ashridge, Hertfordshire, Chiltern Hills, England; Leavesden Studios

APPEARANCES: *Harry Potter and the Sorcerer's Stone, Harry Potter and the Chamber of Secrets, Harry Potter and the Prisoner of Azkaban, Harry Potter and the Goblet of Fire, Harry Potter and the Order of the Phoenix, Harry Potter and the Half-Blood Prince, Harry Potter and the Deathly Hallows – Part 2*

TOP: *Director David Yates on the set of the Forbidden Forest;* RIGHT: *Harry Potter and Draco Malfoy search for an injured unicorn in* Harry Potter and the Sorcerer's Stone.

sawdust were applied in designated areas. In order to secure the lichen—always placed on the north side—the trees were brushed with an adhesive and then the faux plants were blown onto the structure.

In its final iteration, for *Harry Potter and the Deathly Hallows – Part 2*, Pinewood Studios hosted the Forest, which contained sixty trees that were ten feet wide and forty feet tall—the biggest Forbidden Forest to date. Not only were the trees even larger than before, the ground cover was thicker and more verdant. By the time of the eighth film, the painted cyclorama that served as the backdrop to the scenes had grown to six hundred feet in length.

"THE FIRST YEARS PLEASE NOTE THAT THE DARK
FOREST IS STRICTLY FORBIDDEN TO ALL STUDENTS."

Professor Dumbledore, *Harry Potter and the Sorcerer's Stone*

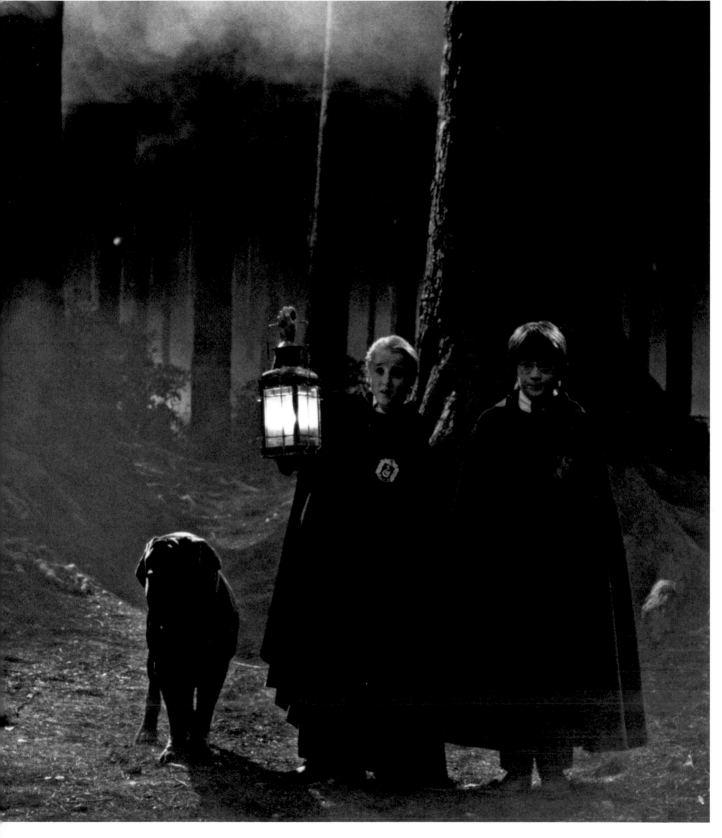

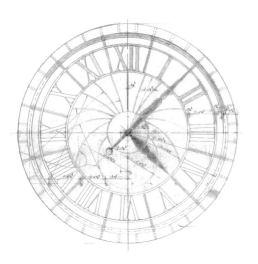

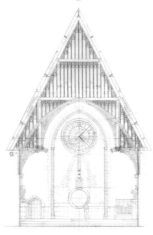

FILMING LOCATION: Leavesden Studios

APPEARANCES: *Harry Potter and the Prisoner of Azkaban, Harry Potter and the Goblet of Fire, Harry Potter and the Order of the Phoenix, Harry Potter and the Half-Blood Prince, Harry Potter and the Deathly Hallows – Part 2*

CLOCK TOWER AND COURTYARD

In addition to new elements being added over the course of the Harry Potter films for story-driven reasons—such as the extension of Hagrid's hut and the design of the Owlery—locations were also rebuilt for visual and thematic goals. This was the case for the Clock Tower and its attached courtyard in *Harry Potter and the Prisoner of Azkaban*. Various Hogwarts courtyards appear in the first two films; most were shot on location, such as at Durham Cathedral and New College at Oxford. But for *Prisoner of Azkaban*, time is an overarching focus in the story, and director Alfonso Cuarón wanted to represent this visually at Hogwarts castle. "It developed over a long period of discussions with Alfonso," recalls Stuart Craig. "Time-turning was the theme, especially of the third act of the film. So references to clocks, references to time, were extremely relevant."

Cuarón also wanted a more connected and logical geography to the school, and so several major revisions folded the new Clock Tower into the Hogwarts profile. In *Prisoner of Azkaban*, the Clock Tower and its courtyard are set at the back of Hogwarts. The students gather there before and after visiting Hogsmeade, and the courtyard is used as another way out of the castle, over a (new) wooden bridge. Cuarón put his own stamp on the courtyard

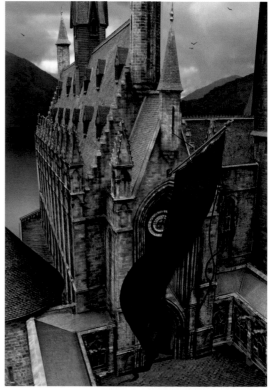

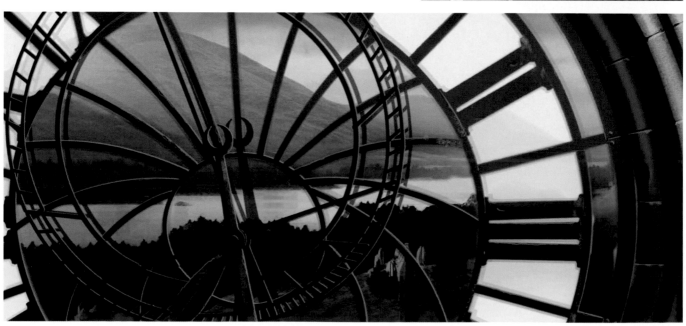

with a reference to his Mexican heritage. The Gothic-arch-topped sculpture around the terrace's fountain features serpents and eagles, which are the coat of arms on the Mexican flag. The view through the clock, which had a transparent face in this film, was toward Hagrid's hut, where Buckbeak's execution was supposed to take place. For *Harry Potter and the Goblet of Fire*, the Clock Tower was moved to the front of Hogwarts—since a reconstructed back entrance was needed for Yule Ball attendees—and turned into part of the entrance hall and viaduct courtyard. As the clock has made its way around the school throughout the films, so has an individual component: Its pendulum is used to monitor the time during Dolores Umbridge's O.W.L. test in *Harry Potter and the Order of the Phoenix*.

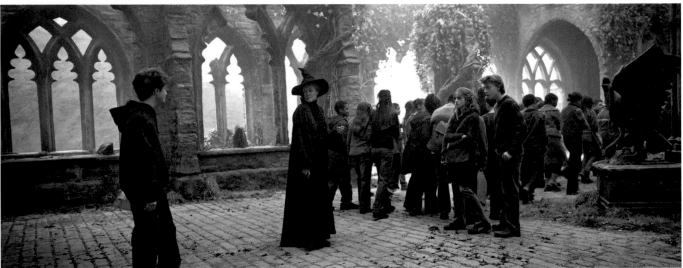

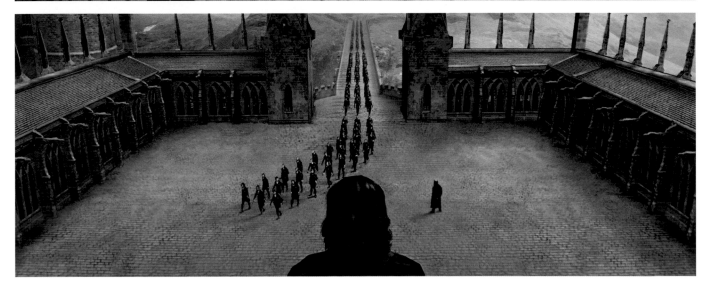

OPPOSITE, CLOCKWISE FROM TOP LEFT: *Building plans for the Clock Tower; concept art by Andrew Williamson provides views of the Clock Tower and clock face;* TOP: *Dermot Power depicted the courtyard in spring;* MIDDLE: *Harry is left behind as the students leave for Hogsmeade in* Harry Potter and the Prisoner of Azkaban; BOTTOM: *Concept art by Andrew Williamson for* Harry Potter and the Deathly Hallows — Part 2 *depicts Severus Snape supervising a stark, grey courtyard.*

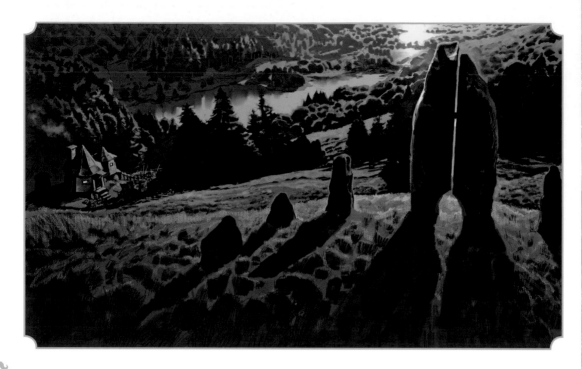

"TO BLOW IT UP? BOOM?"

Neville Longbottom, discussing the destruction of the wooden bridge,
Harry Potter and the Deathly Hallows – Part 2

FILMING LOCATION:
Clachaig Gully, Glencoe,
Scotland

APPEARANCES:
*Harry Potter and the
Prisoner of Azkaban,
Harry Potter and the
Goblet of Fire, Harry
Potter and the Order of
the Phoenix, Harry Potter
and the Half-Blood Prince,
Harry Potter and the
Deathly Hallows – Part 2*

THE BRIDGE AND STONE CIRCLE

To connect the new Clock Tower courtyard and the relocation of Hagrid's hut in *Harry Potter and the Prisoner of Azkaban*, a covered Gothic-style wooden bridge was added. "It was to be two hundred fifty feet long and look very rickety and tumbledown," says art director Alan Gilmore, "leaning from side to side and twisting as it goes, spanning over a little canyon, about halfway between the castle and Hagrid's hut." The bridge was originally intended to be a combination of a miniature model and a short section built in the studio for the actors, with background shots composited over blue screen at a later date. But when the location shoot in Scotland was put together for Hagrid's new hut, Alfonso Cuarón asked if at least part of the bridge could be built there as well. "And to me," says Stuart Craig, "the gauntlet was thrown!" A fifty-foot section of the bridge was prefabricated in London and transported to Scotland. "The location was incredibly windy," Craig recalls. "Extraordinarily windy." The construction of the bridge, with its pieces lifted into place by helicopter, could only take place on non-windy days. "Then a really, really solid steel scaffolding structure was put into place," adds Craig, "to tie that down against the wind. But it looked good, I must say."

The five stone monoliths that were placed at the end of the bridge, before the hilly descent to Hagrid's hut, were designed to look as if they had been there before Hogwarts was built. England and Scotland are known for their Celtic stone circles, the most documented ones being Stonehenge and Avebury. As the purpose of these structures has long been in debate, the filmmakers assigned this one to be a sundial, another reference to time. During the bridge's construction, five very big holes were dug into the earth near it, and a helicopter was used to drop the stones in. Gilmore revels in the actors' reaction to them. "Someone told me that the kids asked Alfonso if he had chosen the location because of the stones. That's very gratifying."

*TOP: Art shows the setting
of Hagrid's new hut near the
stone circle; RIGHT: Concept
art by Andrew Williamson
depicts students approaching
the bridge from the courtyard.*

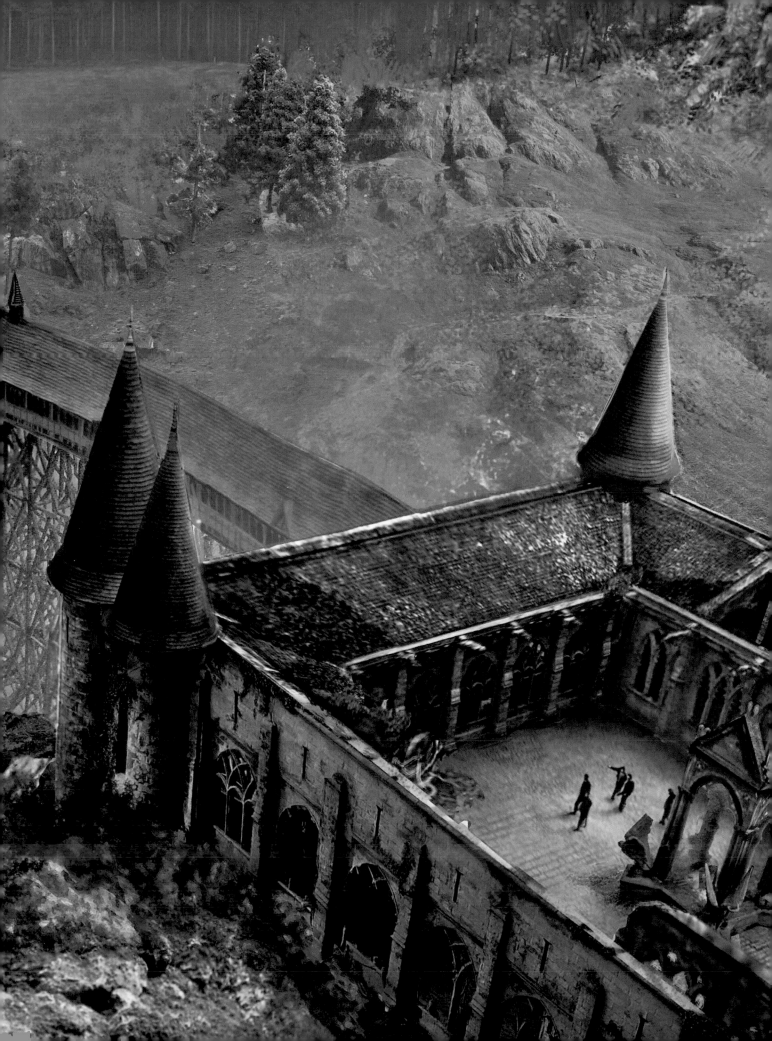

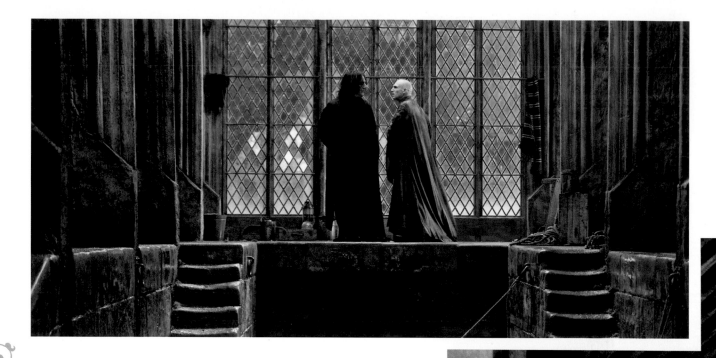

"YOU HAVE YOUR MOTHER'S EYES."

Professor Snape, *Harry Potter and the Deathly Hallows – Part 2*

BOATHOUSE

There are times when turning a book into a movie calls for more "theatrical, operatic locations," says Stuart Craig. In the last book of the series, Severus Snape dies in the Shrieking Shack. "Although the Shrieking Shack, as a movie set, is quite richly decorated," explains Craig, "it's honestly more interesting externally than it is internally." He had always felt that the Hogwarts boathouse, where the first-year students arrive in their boats in *Harry Potter and the Sorcerer's Stone*, had been underused in the films. The set had been intended for *Harry Potter and the Goblet of Fire*, but due to changes in the script, it was never realized. "I was sorry that a potentially interesting set had never been exploited. So we went to J. K. Rowling and asked, specifically, if she minded if Snape died in the boathouse. Thankfully, she agreed." Craig designed the structure in full, giving it walls of windows. "It was a very skeletal Gothic structure with lots and lots of leaded glass. Something like the Crystal Palace." Situated at the bottom of a cliff below Hogwarts, the boathouse would offer "maximum reflection of the burning school. It seemed magical that Hogwarts was on fire above it, and there was a sense of the flame from the fire above being reflected in the glass, also reflected in the water, which in turn reflected back in the glass. That created a very romantic, atmospheric place. A deserving place for Snape to die." After the scene was shot, Alan Rickman, who portrays Severus Snape, expressed his thanks to the designer for the setting, which he said had helped him. "That's so unusual," says Craig, "and so gratifying to know that he was pleased."

ABOVE AND RIGHT: *Lord Voldemort (Ralph Fiennes) and Severus Snape (Alan Rickman) on the boathouse set;* OPPOSITE TOP: *Blueprints for the construction of the boathouse for* Harry Potter and the Deathly Hallows — Part 2.

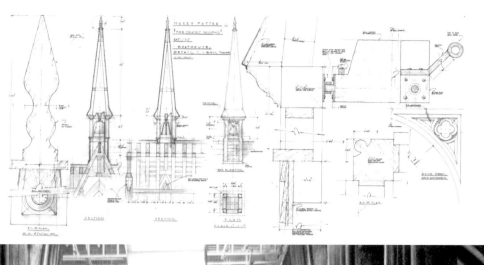

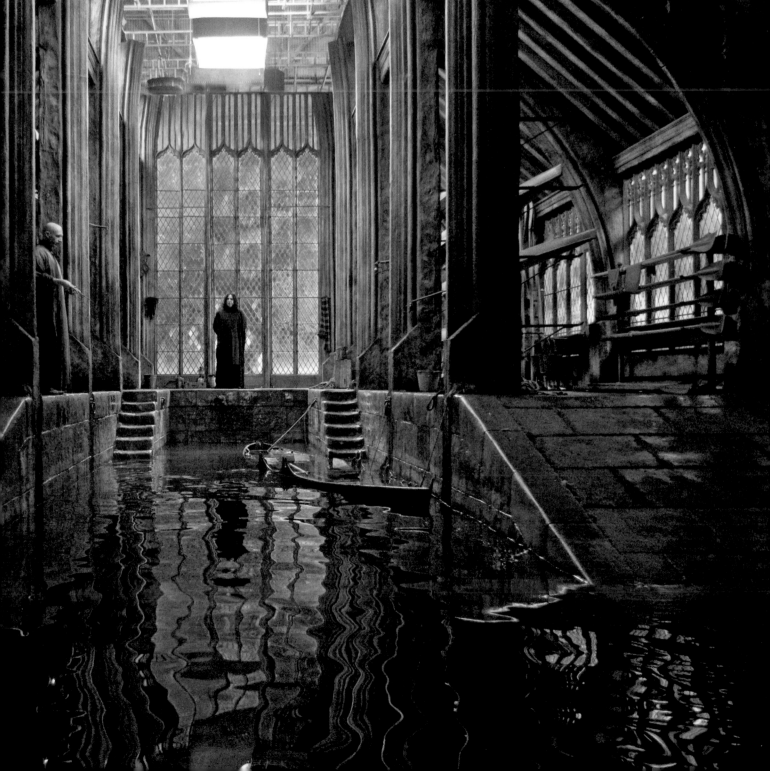

PO Box 3088
San Rafael, CA 94912
www.insighteditions.com

f Find us on Facebook: www.facebook.com/InsightEditions
🐦 Follow us on Twitter: @insighteditions

Library of Congress Cataloging-in-Publication Data available.

ISBN: 978-1-68383-830-2

Publisher: Raoul Goff
President: Kate Jerome
Associate Publisher: Vanessa Lopez
Creative Director: Chrissy Kwasnik
Designer: Judy Wiatrek Trum
Editor: Greg Solano
Managing Editor: Lauren LePera
Senior Production Editor: Rachel Anderson
Production Director/Subsidiary Rights: Lina s Palma
Senior Production Manager: Greg Steffen

Written by Jody Revenson

Insight Editions, in association with Roots of Peace, will plant two trees for each tree used in the manufacturing of this book. Roots of Peace is an internationally renowned humanitarian organization dedicated to eradicating land mines worldwide and converting war-torn lands into productive farms and wildlife habitats. Roots of Peace will plant two million fruit and nut trees in Afghanistan and provide farmers there with the skills and support necessary for sustainable land use.

Manufactured in China by Insight Editions

10 9 8 7 6 5 4 3 2 1